# THE GHOSTS OF
# CHIPPENY HILL

# THE GHOSTS OF CHIPPENY HILL

Myths, Legends, Ghosts, Indians, Witches and Orbs
from the Old Chippeny Hill Area

JUDITH M. GIGUERE

AMERICA
THROUGH TIME®
ADDING COLOR TO AMERICAN HISTORY

America Through Time is an imprint of Fonthill Media LLC
www.through-time.com
office@through-time.com

Published by Arcadia Publishing by arrangement with Fonthill Media LLC
For all general information, please contact Arcadia Publishing:
Telephone: 843-853-2070
Fax: 843-853-0044
E-mail: sales@arcadiapublishing.com
For customer service and orders:
Toll-Free 1-888-313-2665

www.arcadiapublishing.com

First published 2018

Copyright © Judith M. Giguere 2018

ISBN 978-1-63499-040-0

Typeset in Minion Pro 10pt on 13pt
Printed and bound by CPI Group (UK) Ltd, Croydon, CR0 4YY

# ACKNOWLEDGEMENTS

M Y THANKS TO THE MANY individuals that encouraged me in this work and specifically: Dr. Dawn Leger; Leonard Alderman, Burlington Town Historian; Mike Sayman, Bristol Cemetery Commission; Jay Manewitz, Research Librarian Bristol Public Library; Paula and Lori Ciarmella; Karen and Emory Austin; Mike Angelicola, Historic Cemetery Restoration; Mary Carroll, Historic Gravestone Carver Research; Marie MacDermid; Judy Wilks; Linda, Mark and Charlie Austin; Janice Boland; Dr. Howard Meyer; Brian Armbruster; and all my patient friends that listened and helped me in the research and writing of this book.

# CONTENTS

The Legend of Chippeny Hill                                    9

Monument to the Tunxis Indians                               11

Compounce's Iron Kettle                                      13

The White Wolf of Peacedale                                  14

The Monster of the Marsh                                     16

The Disappearance of Nehemiah Manross                        18

The Meadows of Thomas Hancock                                19

Gold in the Holt District                                    21

The Mystery of John Scott's Disappearance                    22

The Mysterious Swamp                                         24

The Disappearance of the Old Couple's House                  27

Of Stones and Bones                                          29

The Legend of Todd Hollow                                    32

The Ghost Dog of Town Hill                                   35

Who Was the Leatherman?                                      36

Ancient Milestone Marker                                     38

The Green Lady—Or Not?                                       39

The Ghosts of Lamson Corners                                 41

The Mysterious Tale of the Old Lead Mine                     43

Trial by Gossip                                              45

Goody Norton and the Trial by Water                          47

Things That Go Bump in the Night                             50

The Ascension of Ashael (Well, Maybe)                        52

The Spirit Follower of Peck Lane                             53

The Forgotten Witch                                          53

The Pennsylvania Hermit                                      55

The Old Episcopal Church in New Cambridge                    57

Is Tories Den Haunted?                                        61

The Smallpox Vaccine                                          65

Captain Wilson and the Sons of Liberty                        66

Ruth Graves and the Conch Shell                               69

Stephen Graves's Cow                                          71

The Ghostly Tale of Moses Dunbar's Grave                      73

The Determination of Matthias Leaming                         76

Isaac Shelton, the Unrepentant Tory                           77

The Hero and the Villain                                      79

Early New Cambridge                                           83

The Paupers of East Church                                    84

Following the North Star                                      87

Little Girl Lost                                              88

The Passage of Time                                           92

Bibliography                                                  95

# THE LEGEND OF CHIPPENY HILL

**L**ONG AGO WHEN TIMES WERE simpler and the world much bigger, the woodlands and meadows stretched from horizon to horizon. Everywhere were birds, bears, and all manner of wild creatures more varied than one could imagine. Butterflies and birds decorated the fields and skies with a multitude of rainbow colors of every size and shape. Native Americans had sporadic camps and broke the wilds with minimal trails. They lived simply, taking only what they needed from the wilderness and relishing its diversity and multitudes of game. A few lonely souls punctuated the Chippeny backwoods, named for a singular Native American called "Cochipianee."

The first to call this area home was Cochipianee, who was most likely a member of the chief's council, as the *pianes* of his name suggests. He was given the lands as his hunting preserve. Often, the chief of the tribe could claim a certain territory as a specific hunting area for his favorites or as a reward for some special service to the tribe or the chief. Little is recorded of Cochipianee other than his fondness for apple cider. His name was shortened and claimed for this portion of Bristol, Plymouth, and Harwinton. It became "Chippeny Hill" and later, "Chippens Hill."

Paleo-Indians lived in New England as early as 10,000 BC and by 6,000 BC populations successfully made their homes in this environment. Hunting was primary to feed the tribes with campsites changing every few days. Food gathering supplemented their diets. Bowls were carved from soapstone at such locations as the former soapstone quarry on Federal Hill in Bristol. Corn, beans, pumpkins and squash were planted and harvested on the lands of nearby Indian Heaven—named for its plentiful game.

Maybe it was the beauty of the ledges, rich variety of game, thriving varieties of trees reaching to the stars, blueberries, blackberries and masses of strawberries that drew the first settlers to Chippeny Hill. The hill and its mile of ledges, bright sunshine and bitter winter winds created the tenacity of its residents. To the White Wolf, the Monster of the Marsh and other mysterious creatures of reality and legend that called the Hill home, it instilled a rare resolve to survive and flourish.

It is beauty but with thorns. A hill so high one can see for miles, to Hartford and beyond, yet it could also be treacherous. The frigid winds and winter snows claimed many. It could snow for days, creating drifts far higher than those of the valley. The rivers had a sheer

strength of will with melting snows that could wash away all in its path. Sometimes it seemed that the only thing to survive were the numerous rocks and ledges.

Yet the splendor and fertile soil of the pasture lands of Chippeny Hill spoke to humans. To Native Americans it was rich hunting territory. It was wonderful territory for gatherers, too. Later, to new settlers, it was the richness that drew them to the struggle to survive. The contrast of magnificence and treachery drew brave souls who chose to call it home. It mirrored their lives. Precarious in a new land but worth its challenge in freedom.

It was the Tunxis Sepus or "bend in the little river" band that lived on the plains of Farmington. The band was known as the "Tunxis" Indians. Some also lived near Chippeny Hill and surrounding lands. Cochipianee was of this tribe. The Tunxis were peaceful Indians often seeking the white settlers for protection. Many became Christian and went to school. As time passed, tensions were inevitable. The two cultures were too different to fully converge. Communication over what each perceived as cultural norms was confusing. Neither side really understood the other and they lived warily of one another. Later some of the Tunxis Indians joined the Stockbridge Indians, while others joined the Oneida tribe. The former Indian residents would sometimes come back to visit friends and family holding powwows and dances at their old burying grounds. Finally, by 1820, the last full-blooded Tunxis male died, and not long after, his wife. Times had changed.

*The view from the top of Chippeny Hill.*

The Plymouth side of Chippeny is called "East Church." It evolved as its own district largely because of internal disputes within the churches and the formation of our new nation. Most East Church residents maintained their loyalty to the King of England, much to the chagrin of Captain Wilson. Captain Wilson of Harwinton was the leader of the local band of the Sons of Liberty. East Church Tories were favorite targets of Captain Wilson's raids. The woods behind the Old Marsh contains a cave known as Tories Den, a noted hiding place for the Loyalists or Tories. St. Matthew's Episcopal Church was the center of the community after the Revolutionary War. Anglican Churches closed during Revolutionary War times as a matter of safety. Church goers would worship in secret at individual homes or at Tories Den.

Indians made homes around the Old Marsh and Chippeny Hill. The Indians were the first to hear the howls of the Monster of the Marsh and to see the White Wolf prowl the Hill. It has always been a mysterious place. The predecessors of Chippeny Hill and East Church were spoken of in whispers and sideways glances by later generations, lest a ghostly former resident hear the conversations.

From Indians to rebels, to the ever-pervasive Sons of Liberty raids, to hangings, ghost stories and witches—it is mysterious indeed!

# MONUMENT TO THE TUNXIS INDIANS

THE TUNXIS WERE NOT FORGOTTEN by Farmington. The Town of Farmington owed much to the peaceful Tunxis. Perhaps if the warlike Pequots or the Mohawks had claimed the lands of Farmington, history might have had a different outcome.

In 1840 a large block of red sandstone was carved as a monument to the Tunxis Indians. The site is located at Farmington's Riverside Cemetery which once was an Indian burial ground. The scattered bones were gathered and interred beneath it. The inscriptions read:

IN MEMORY OF THE INDIAN RACE; ESPECIALLY
OF THE TUNXIS TRIBE, THE ANCIENT
TENANTS OF THESE GROUNDS.

The many human skeletons here discovered confirm the tradition that this spot was formerly an Indian burying-place. Tradition further declares it to be the ground on which a sanguinary battle was fought between the Tunxis and the Stockbridge tribes. Some of their scattered remains have been re-interred beneath this stone.

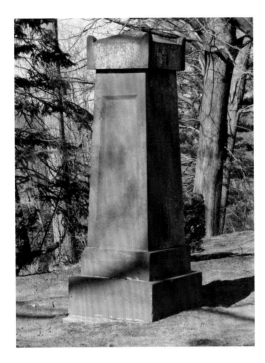

*A monument erected to honor the Tunxis Indians that once made Farmington their home.*

On the other side of the monument is a poem by Hartford poet Lydia Huntley Sigourney:

> Chieftains of a vanished race,
> In your ancient burial place,
> By your father's ashes blest,
> Now in peace securely rest.
> Since on life you looked your last,
> Changes o'er your land have passed;
> Strangers came with iron sway,
> And your tribes have passed away.
> But your fate shall cherished be,
> In the strangers' memory;
> Virtue long her watch shall keep,
> Where the red-men's ashes sleep.

It's a nice tribute to the long-gone Tunxis, but there are some that feel appreciation for the Tunxis was rather late. The monument could be considered a poor tribute—far more could have been done to appreciate the Tunxis while they were present instead of after they were gone.

*The view from Riverside Cemetery in Farmington of the bend in the river site of the village of Tunxis Indians. The village was in the flat pasture land in the distance.*

# COMPOUNCE'S IRON KETTLE

IN THE FAR SECTION OF New Cambridge toward the Southington town line is a glacial formation known as a kettle hole. Kettle holes were formed when the great glacier that once covered New England receded. Chunks of ice were left in soft sand. As the ice chunk melted, it formed an impression called a "kettle hole." Most kettle holes eventually filled with water to form many lakes and ponds throughout New England. Such a kettle hole formed the lake named for the Indian that once called it and the surrounding caves home.

Portions of Tunxis Indian lands were given by the reigning chief to elders, or to honor those he believed were deserving. The lands were territories, not possessions. A Tunxis Indian elder named "Compounce" was given the lands by the lake that now bears his name, "Lake Compounce," by the Chief of the Farmington Tunxis tribe. His Indian name may have been quite different but it was considered unpronounceable by the English settlers and was shortened to Compounce. Compounce and his wife lived in a cave by his lake. It was a quiet place with accessible hunting and fishing. They lived there for many years in their little corner of the universe. Occasionally other Indians came visiting or passed through the area. It was one of the places where Tunxis Indians buried their dead in the quiet of the Indian trail near the birches by the lake.

The arrival of the English settlers brought new things the Indians had never seen. Compounce, upon prolonged negotiations, gave title to his lands in exchange for an iron kettle. Native Americans were not known for metal work, so owning the iron kettle was quite a delightful treasure to behold! Compounce was so pleased with his kettle that when presented a land transfer document, his signature was a picture of his prize. Native Americans did not believe in title to land in the same way as the English settlers. To Native Americans, the land is holy, it cannot be owned by anyone, singly or as a group. It is the Earth Mother who shares her bounty with those that care for her. Mother Earth is not a possession, she is a living entity. Apparently either Compounce didn't understand, or the iron kettle was too unique to risk losing.

The legend handed down through generations was that Compounce and his wife met their fate paddling the lake in their iron kettle. It's a sad tale, but unlikely. Undoubtedly, the kettle was too heavy to float and even less likely float with two individuals in it—if they could fit into it. Another tale suggests that Compounce met his fate in a drunken bet to swim the lake with his prize kettle on his head. Ghosts have been seen near the birch-tree-lined entrance road to the lake. Some claim to have seen the Chief in his kettle drifting across the lake, others have encountered ghostly images near the caves by the lake. Each is an interesting tale, but perhaps the ghost is Compounce paying penance to Mother Earth for selling the ancestral kettle hole lake for an iron "kettle."

# THE WHITE WOLF OF PEACEDALE

THE FORESTS WERE ONCE DENSE, punctuated by a few partings of the underbrush, trails where the wolf, deer and forest creatures roamed. The trails were barely noticeable except to the most skilled in the ways of the woodlands. The Native American cherished the forest and its inhabitants. He knew the birds, the rocks, the rivers and all manner of creatures. It was then the White Wolf shared her territory with the Indians. She was revered for her skill to outwit her enemies, protect her family and the ability to pass unseen. Indian lore considers the White Wolf as a shape shifter or a ghostlike creature who comes to those in need of her guidance and give them strength to face a pending challenge.

The White Wolf is symbolic of stamina, strength, courage and the embodiment of freedom. Wolves are intensely loyal and mate for life, and fiercely protect their family. The wolf is a pathfinder guided by knowledge of the forest and eagerly adapts to its changing

*The ancient territory of the White Wolf that was a former burial place of Tunxis Indians.*

patterns. The appearance of the White Wolf is an omen in times of trouble. She appears to those facing difficult decisions or coping with loss. It is believed that when the White Wolf appears to you that it is for you to learn to face your deepest fears, the kind of fears that hold you back. Her presence will help you to learn to find your freedom. The wolf may have selected you because you are a teacher and can teach others, or to teach you to expand your personal views.

The White Wolf roamed the verdant fields and deciduous forests at will. She shared the land with the Indians who respected and revered her as a creation of Mother Earth. Peacedale Street was one of the places the Tunxis Indians buried their dead. The White Wolf watched over their dead as she roamed the Peacedale area in the time before new settlers with different values disrupted the established way of life.

With the new settlers, she lost her home lands. The lands were broken up by farms and fields and strangers that did not respect her. Her friends, the Indian, had died or moved on. The White Wolf slipped into legend. The Spirit of the White Wolf now roams the forests and lands of Peacedale Street near the burial lands of her former friends. In her loneliness, she sometimes appears near the stream to the broken hearted or those seeking answers.

Perhaps White Wolf appears because she can relate to those in mourning. She too lost her world. Those who have seen the White Wolf say she does not appear sinister. She comes as a kindly soul—a strong force to protect those in need or teach them to look inward for

the new path they must follow. Do not be frightened if she appears to you—be grateful and listen to her voice. She is there to guide you to where you need to be.

# THE MONSTER OF THE MARSH

**B**ACK IN THE EARLY DAYS, when witches roamed, fear and damnation proliferated in the hellfire and brimstone pulpits of the early churches. Settlements were few and far between. The dense forests held animals yet unknown and unnamed. Tales are told of red glowing eyes on the cliff tops of the ledges of Chippeny Hill. The glowing eyes seem to follow one home on cold, dark, moonless nights. Strange crying or screaming sounds could be heard when the disappearances first began. Shrieking sounds on the nights of the winter full moon, terrifying screams and red, glowing eyes seemed to be everywhere, even in the trees.

So it was in early New Cambridge, in the section known as Chippeny Hill, which was the early community near the dense wilderness of the Old Marsh. The Old Marsh was a

*The pond and dense pine forests known as the Old Marsh.*

primary source of water and was surrounded by deep untraveled woods. It was home to many unknown creatures large and small. Of course, the settlement was new and no one could describe how such a newly settled rough country like the Marsh could be "old" in anyone's memory, but pristine beauty gave it the air of mystery, even according to the Native Americans.

The first disappearances were a few small animals, a goat, then a cow or two. The Native Americans warned of a demon in the Old Marsh that claimed anyone or any creature it pleased. The Native Americans were well aware of the vile presence. It seemed in the severest of winters strange happenings were more common. The creature became hungrier as winter snows got deeper. After a few winters, stories of the "Monster of the Marsh" grew.

A tale is told of one October as the full, pumpkin orange Harvest Moon glowed brightly. It was welcoming in the first fast moving blizzard of the winter season. The air was still, and one could hear the sleet pinching the warm ground and overtaking the last remnants of kinder, gentler times. The encroaching cold air cut the last vestiges of fall. It took with it any hope of easier, moderate weather. A child had gone to the shed to milk the cow to share some milk with an ailing neighbor. In colonial times the responsibilities of children were high. Life took a toll on everyone and everyone was expected to contribute their share. Neighbors helped each other—it was not just courtesy, but necessary.

Soon dark, grey murky clouds covered the Harvest Moon and heavy snow had been falling when the noises came. Was it the North Wind telling the small community winter was here? Was it just the crumpled old shack announcing the pressing cold? Or maybe it was something else.

The child had not returned from her chores. It snowed for two days, drifting six or more feet high in places. No trace of the missing child could be found. Jointly and severally the community searched, clamoring through the hills and the snow as best they could. Some of the boys, as a group, of course, ventured into the Pine Ledges of the Old Marsh woodlands. As soon as they crossed into the dark realm of pines, ungodly screams pierced the cold morning. The boys swore red glowing eyes followed them. Their youthful bravado melted quickly. Fearfully they returned home.

No trace was ever found of the child. Disappearances continued but children were never again let out at dusk. Gradually those that "knew" moved away. They feared for their lives and that next time, it might be their child carried off by the Monster of the Marsh. Eventually, the sounds echoed in the distance and the eyes faded into the past. People moved away. Many houses became empty and only the foundations were left. The community passed into history. The finality of the isolated, empty, spooky woods formed the legend of the Monster of the Old Marsh until it faded off into the distant past.

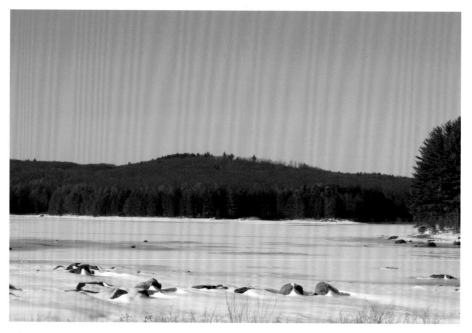

*The Old Marsh in winter.*

# THE DISAPPEARANCE OF NEHEMIAH MANROSS

N EHEMIAH MANROSS, SR. WAS BORN was about 1690 and later fled Scotland because of religious prosecution. The name "Manross" transitioned over time from "Montrose" into "Manross." Not long after his arrival in Lebanon, Connecticut, he married Esther Bishop. The year was 1710. Several children were born to them, the first a girl named Ruth. The second was a son named after his father. With the promise of available land, the family moved in 1728 when Bristol was known as New Cambridge. He settled his family in the Forestville district, near the area set aside for an Indian reservation.

Nehemiah was a very capable man and soon was appointed moderator of the church. His abilities were recognized and he was chosen to contract for the construction of the meeting house and to be the person to make sure the work was done on time and properly. He was a hard worker and a credit to the community, yet one day he left home to go to Hartford on business and never returned.

No confirmation or actual evidence ever surfaced. It was believed that he was ambushed and killed by Indians not far from his home. The Manross family remained in Forestville.

# MEET

## THE AUTHOR

### THE GHOSTS OF CHIPPENY HILL

JUDITH M. GIGUERE

Myths, Legends, Ghosts, Indians, Witches and Orbs
from the Old Chippeny Hill Area

*Saturday, February 24th at 1:00 p.m.*

*Barnes & Noble*
*235 Union Street*
*Waterbury, CT 06706*

A later Manross named Newton was a professor of chemistry and philosophy at Amherst College in Massachusetts. He was a graduate of Yale, receiving his Ph.D. from the University of Gottingen, Germany, in 1852. He enlisted in the Union Army during the Civil War. He received the commission of captain of Company K of the 16th Connecticut regiment.

Captain Manross was killed at Antietam. His brothers John and Eli also served. Eli was a sergeant in the 5th Connecticut and wounded at the Chancellorsville in 1863. John was discharged due to disease. Later generations of the Manross family donated the Fredrick N. Manross Library to the City of Bristol. The Manross family were also noted clockmakers in Bristol. The patriarch, Nehemiah, may have been lost, but his family left an honorable legacy.

# THE MEADOWS OF THOMAS HANCOCK

A S EARLY AS 1634 AND 1635, incursions were made into Connecticut. Settlements began in Wethersfield, Windsor and Hartford. Farmington began to be settled about 1640. Settlements away from navigable waters were very new. Travel and shipping by water was far easier than by ox cart or horse. The only roads were pathways made by Indians. The first recorded deed given by Native Americans was in the Naugatuck Valley to grant the right to mine black lead. Other deeds signed by Native Americans surrendered land that made up the State of Connecticut.

Farms were scattered but increasing as land became available. The original owner of the meadows between Greystone and Waterbury was Thomas Hancock. He signed the Mattatuck Articles that defined the community's rights and the rights of prospective land owners. It was expected that a home of specific measurements and quality be built and occupied within a certain about of time. Thomas began his home but appears to have been gone most of the time. This was not appropriate, according to the Mattatuck Articles.

Mr. Hancock evidently was spending most of his time in pursuit of Miss Rachael Leonard. It was three years before she consented. Mr. and Mrs. Hancock settled in the partially built home and by 1683; the home was not completed according to requirements. For whatever reason, possibly Mrs. Hancock did not like the remoteness and threat of Indian attacks, they left their homestead. Thomas became the jailer at Hartford prison. The land changed owners many times, but it still retains his name—Hancock Meadows and Hancock Brook.

*One of the small brooks at Hancock Meadows.*

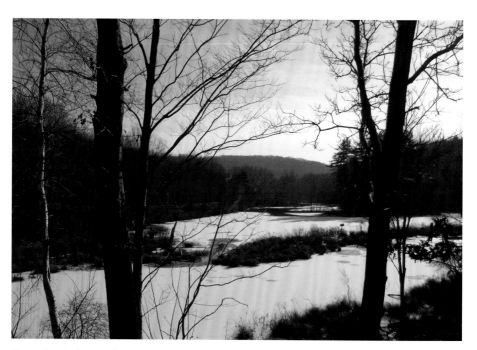

*Hancock Meadows in the snow.*

# GOLD IN THE HOLT DISTRICT

I T WAS 1848 WHEN GOLD was discovered at Sutter's Mill and news of the California Gold Rush inundated the world. Excitement was everywhere. The population of California soared as people poured in first from the west coast, then the east and the world in search of wealth. Of course, wealth, even a little bit, could take most of them out of the meagerness of their lives. Being able to afford new clothes, warmth, a comfortable home and most of all food, certainly offered many a new existence.

Holt District, named for a large land owner named Holt, was no different. One day two brothers, Edward and Elmer, decided to search for themselves. Unable to leave Mom's cooking, the brothers chose to see what they could find in the woods of the Holt District. Edward and Elmer set out early in the morning, after a full breakfast that included a tankard or two of local hard cider that Mom didn't know about. They trudged and trudged through the mud, rocks and minimal trails. The cider made both rather silly. They were rather silly to begin with, but this exacerbated the condition.

It was later in the afternoon and still they had not reached anything that looked to them like it might hold hidden treasure. Tired and cranky Elmer decided to dig alongside the brook. That particular spot appeared no different than any of the others to Edward, but he agreed with this older brother because it was easier. Taking up the pick axe, Edward began to dig. The ground was hard and unforgiving.

Elmer grunted but reluctantly picked up the shovel. Elmer was the older and didn't feel it was his responsibility to do any of the manual labor; after all, he was the brains of this operation. Together the boys dug until they hit upon a flat rock about two feet long. They hit it again and again and to their chagrin, nothing happened. Finally, Edward decided to lift a corner of the rock.

Both boys crunched up and each took a corner of the rock. With groans and grumbles they lifted. Edward leaned over the hole and brushed off some dirt, hopeful of a miraculous find of gold. Elmer also leaned over to see what was going on and brushed off some dirt to reveal a skull. With an awful shriek both boys jumped hysterically clinging to each other. When Edward jumped, he tripped over the pick axe.

Not thinking, he saw blood on his leg. Panting and in a loud agitated voice, he screamed, "He's got me, he's got me! Look—BLOOD!"

The boys looked at each other in horror. Puffing and puffing, Edward screamed, "It's the old chief, he grabbed my leg!"

Elmer clutched at Edward's jacket, seeing the blood on his brother's leg, grabbed him and they ran and ran. Once home both collapsed on the ground.

Edward took off his boot. He asked Elmer, "Is my foot still there? Is it? Is it?" He had closed his eyes as he took off his boot, fearing that in revenge of the old chief had taken his foot.

Elmer began laughing. Seeing the horror on his brother's face, he laughed more and finally replied, "Look you fool! You must have cut your foot when you tripped over the pick!"

Edward sheepishly took a deep breath and looked down. "Yea, well, I'm sure never going back there!"

Edward and Elmer never did find gold or go looking for it again. Mom's cooking was good enough for them and far better than being rich!

# THE MYSTERY OF JOHN SCOTT'S DISAPPEARANCE

THE MYSTERY OF THE SCOTT murder is written in several early historical texts. It is as varied as it is enigmatic. It's hard to tell which is true and which is just a jumbled mass of incidents all rolled into one legend.

It was 1657. Alarms rang out! Roaming bands of Indians from Canada had captured John Scott and his two sons. John's tongue had been cut out to keep him from raising an alarm. It was frightening for the whole community. Everyone was moved into the security of palisaded homes. The home guard patrolled until John's broken body was found near Reynolds Bridge (Thomaston). It was buried there and the communities mourned and feared the next attack. Or was it Jonathan that was taken and his right thumb cut off to hinder escape? Were his sons also captured?

Twenty acres in the Great Swamp in Farmington were given to Joseph Scott by his father, Edmund, in 1690. Great Swamp later became Scott's Swamp courtesy of Joseph. Jonathan Scott was given lands in Waterbury and some meadow lands in Farmington. A short time later, Joseph Scott was given a "soldier's lot" in Farmington in recognition of his service to the country. Joseph also claimed lands in the Poland section of Bristol. Joseph, as a condition of the gift of land, was required to attend church regularly and live peacefully.

A 100-year-old gentleman of Farmington relayed the tale told to him by his father of Jonathan Scott living at Scott's Swamp. The story began with Indians seeking bounties to be paid by the French for scalps. First an attempt was made to capture a man named Hart but his dogs frightened them away. Next as the Indians continued to search for potential victims, they found too many guards and populated houses so they moved on. The Indians found Jonathan Scott. He was captured with two of his sons, John and Jonathan Jr. Jonathan's wife, Hannah Hawks Scott, had already suffered great tragedy. In 1704, her mother, brother, and brother's wife along with their three children were killed

in the Deerfield, Massachusetts, massacre. Hannah's sister was captured and died on the journey to captivity in Canada. Poor tragic Hannah!

Another story relates that in Bristol around 1708, John Scott was clearing his land when he was captured by a party of Indians, tortured and killed. Legend states that his screams were heard for miles. Neighbors were afraid to come to his aid, fearful that they might be next. This is problematic as there were no neighbors close enough to hear any screams. Yet, another legend states that in a part of Thomaston known as Reynolds Bridge, a member of the Scott family was killed there, his grave having been marked near a large cave. Families were generally very large in early history and sons were the only ones that could inherit property. It is very hard to sort out which son was at which location or if it is myth or reality.

The settlers were fearful and at times Indian raids caused great concern. Settlers tending the fields worked in pairs, one to work and the other to watch. Constables were frequently placed as guards. The sound of gunfire frightened everyone as it was not known if it was a hunter, a warning shot, or a potential threat in the making. Even though the Tunxis Indians were friendly, often seeking protection of the settlers, the fear was real. Trusted Indians were required to wear something white upon their heads to differentiate from those to be feared.

So which was the real story, if any? Most likely it was Joseph Scott that was killed around February 1708. His name does not appear on historic records after that date. Jonathan Scott appears to have been captured in 1710 and held hostage in Canada. Jonathan reappears on town records in October 1712, requesting financial relief for the loss of one thumb that had been severed by his captors. Jonathan's son, John, seems to have been captured at a later date around 1721. There is no record of John's return, or of his death. Some stories claim two of Scott's sons, both John and Jonathan Jr., were captured, but there are no records to support it. Apparently the stories of Joseph, Jonathan and John became entwined over the years with retelling.

To sum up, after untangling old stories and old town records: The grave at Reynolds Bridge must be Joseph, not Jonathan. Joseph was taken on Fall Mountain in Bristol and killed near the rocks by Reynolds Bridge. Jonathan was captured and held hostage but returned and later captured again and returned. Jonathan's son, Jonathan, was apparently never captured. Jonathan's son, John, was captured and never returned.

Confused? Let it suffice that this family certainly had more than their share of misadventures and tragedy!

# THE MYSTERIOUS SWAMP

**T**HE LAND SET ASIDE FOR an Indian named Poland holds the river that bears his name. Some of the ponds created by the river are hidden in the woods to this day and some are best if they remain hidden. There are many small ponds in Poland's woods, but only one is considered "the Mysterious Swamp." No one will go there because of the legends of unearthly things that live in the pond. It's the 21st century and we like to think these things no longer matter, but ask anyone that considers taking the trail by the Mysterious Swamp and the warning will be repeated.

Parts of the old trail were worn down to gravel through generations of water runoff. Here the sun only peeped in through the canopy of twisted old trees. Several small brooks fed the skunk cabbage of the black water pond. There was a Jurassic sense to it because it only held a small amount of water but enough to sustain a few scraggly trees that looked as if they had been trimmed by herbivorous dinosaurs. The trees never seemed to get any bigger. Remnants of downed trees formed a clumsy bridge over the northern end of the swamp.

The path around the dismal swampy pond always looked spooky, as the trees closed in to engulf anyone or anything that passes this way. It seemed to take on a life of its own. At the north end, where the water was at its lowest, the Mysterious Swamp seemed to pulsate or breathe on

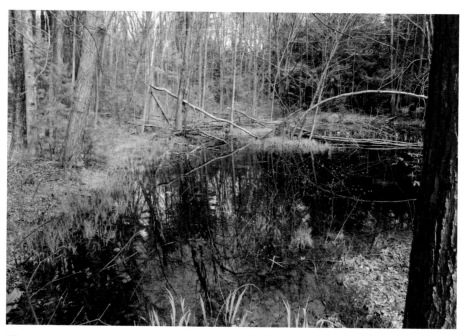

*The Mysterious Swamp.*

its own—as if waiting or for a yet unidentified purpose. It's the trees that caused the pulsations as they were partially underwater and grown together. The roots were joined like a rug causing the trees to move in heavy rains as the water cycles on its way. No one knows how deep the pond might have been because of the stories of images of faces seen in the water. Reflections? Imagination? Yet once past the swamp, the woodland opened up to become green again. It was as if one had passed through purgatory into Heaven. Even so, no one wanted to venture out to the center of the pond to find out if the stories of faces were real, so the legend continues.

There is no sign of the ancient beavers that may have formed the pond, which makes one wonder why it's there at all. The only way the pond appears to remain is by the flotilla of tight trees and tree roots collected with mud and rocks inhibiting the natural flow of water. Sounds simple enough, right? Until the voices begin. Maybe it's the wind teasing the trees? Or could it be the ogres our grandmothers told us about? Could the voices be the sounds of the water trying to escape its murky existence?

Interestingly enough, the Mysterious Swamp is located behind the grammar school. After school, the path that leads past the pond is the quickest way home. It's okay unless it is getting late. Grandmothers tell of a little girl named Kate who often walked home past the pond. She wasn't afraid, or so she said. It was silly stuff, she thought. Kate refused to heed the warnings. She wasn't afraid of the gooey mist either, and voices—how silly! Faces in the water—really? A pond swallowing its next victim—ridiculous, she said.

*Skunk cabbage.*

The day was getting late. Kate knew she should take the long way home but decided that if she ran, she could get past the pond before the ogres come out. Brave as she was, Kate really didn't want to find out if ogres were real. Kate looked up at the darkening sky. She bent and picked up a small stone and tossed it into the pond. The pond gulped and the stone was gone. A breeze touched her hair and rustled the leaves. Kate swatted at it. Mosquitos—yuck, she thought. An eerie silence prevailed.

A green mist arose from behind the Stonehenge-like gathering of boulders opposite the swamp. Silently, stealthily and coldly, the mist crept toward Kate. The birds became silent. Nothing moved, including Kate. She waited, holding her breath to listen for anything besides the silence. The mist gained strength and hovered above Kate. Kate shivered but did not notice the mist right away. Kate sensed something around her. She looked around to see a green shape approaching. She dropped her school books and began to run. It was too late, and the mist enveloped her.

Kate's grandmother didn't notice Kate was missing right away. If Kate had taken the long way home after school she would be late. When Kate didn't come home by dinner time, she knew something had happened. Frantic, the police were called and a search party formed for early the next day. The police used dogs, ATVs, horses and a multitude of volunteers for the search. It continued for hours with little result. The only thing the search party ever found was one shoe and Kate's school books. Neither Kate nor her remains were ever found, not near the Mysterious Swamp or anywhere in Poland's woods.

The Mysterious Swamp has been filled and now is a baseball field for the grammar school. The parents felt it was a fitting end. They hoped the stories would stop. Possibly the voices of children playing would scare off the evil that permeated the former pond. They wanted the new ball field to chase away the Spirits of the Swamp. The baseball field, it was hoped, would take away the mystery and memories of Kate's disappearance and make something good. The Stonehenge of rocks was removed to be replaced with bleachers filled with cheering parents on Friday nights.

Many years have passed. Many children have played at the field, yet never after a rain. A large puddle forms by the pitcher's mound. Water seeps into the field from the unforgiving swamp that won't let go. No one is there now when the voices cry and when Kate's face appears in the puddle. No one plays baseball in the rain. Kate is nearly forgotten—but not by the Mysterious Swamp that claimed her. Was it the ogre, a troll, the wind or did it ever happen? No one wants to know if it was real or just an old story.

# THE DISAPPEARANCE OF THE OLD COUPLE'S HOUSE

NOT ALL THAT LONG AGO, or so it seems, the property along old Route 8 was sold. It's a few miles west of Chippeny Hill but at the same time, nearly as rural. An elderly couple owned the farm and refused to sell. It didn't matter what developers offered, they would not sell. After they died, their children considered giving in to the monetary gains possible by the sale of the family farm.

James met Molly when both were quite young. Molly was a charming little thing with long braids, bows and an apron. James, a shoemaker's son, would soon leave school to apprentice with his father. Unable to be separated from Molly, he proposed to her one day after school. She accepted. Both were only sixteen. They moved into the small room behind James's father's shop. Molly took in sewing and ironing while James worked. They saved and saved and finally were able to buy the farm with the giant elm trees near the river.

Years passed and the happy couple was blessed with twelve children. It was a happy, busy life. The farm house was expanded several times to accommodate the growing family. The additions gave the house a funny shape, like children's building blocks scattered but connected, but it was a home filled with love. The children grew up and went their separate ways. The old couple remained in the home that they had shared for so many years. Children's voices no longer rang in the halls and there were no footsteps galloping up and down the stairs but it was still home to Molly and James. It was filled with many happy and even some sad memories of their life together.

Driving past the house, one could see the old couple sitting near each other in their rocking chairs on the porch. Contentedly rocking and sometimes sleeping, other times chatting but always together. It was a sad day when Molly died. Molly was so quiet James thought she was asleep. Worried, he finally checked her pulse but it was too late. Ambulances parked in front of the house. The emergency medical personnel tried to bring Molly back but they could not. Poor James! His heart was broken. They had spent nearly 70 years together! How could he go on? A few days later, ambulances returned. This time it was for James. A neighbor had seen him collapse in his front yard. His heart had stopped. Apparently he was unable to go on without the love of his life.

Within a week, developers charged in to the grieving family with seemly kind condolences. Kind, but not real. They really wanted the land so the developers offered generous sums of money. The children countered with a cohesive block of lawyers of their own. They had decided the only right thing to do was to sell the farm to the cemetery association, and the first burial plots would be for James and Molly. They would never have to leave their beloved farm again. And so it was sealed.

*An old forgotten grave.*

The very next day the process to tear down the house began, seemingly before the ink was even dry on the agreement. Bulldozers and other heavy equipment tore down the house, filled in the cellar and the root cellar. The elm tree witnesses were removed as well. A road was built. The farm land was marked off with a grid for graves. Shrubs were planted and all trace of the old homestead was gone—or so they thought.

On the darkest Halloween of the past decade, teenagers Michael and Jason took their little sister for a drive through the graveyard. They figured it would be fun to scare her, as big brothers would. On the way they told her all kinds of ghost stories and made up a few new ones. Michael and Jason could see Lorry was becoming properly frightened. This would be fun, they thought. Upon arrival at the entrance to the new cemetery, the moon made a quick appearance then disappeared again. The only light was the headlights of Michael's car.

A short distance into the cemetery, a mist appeared, but no one thought too much of it as it was October. The mist became heavier, then cleared at the location of the farm house. The old house was visible in its former location, with James and Molly seated in their rocking chairs on the porch as if nothing had ever changed. Lorry screamed. Michael screamed and Jason laughed at them both until he looked up from the back seat to see the house with James and Molly peacefully rocking on the porch.

Jason stuttered and Michael hit the gas in reverse to quickly back out of the cemetery. They were panting, screaming, chattering, shaking and all talking at once. They could not believe what they saw! The brakes squealed and tires burned as Michael tore off out of the cemetery.

A few nights later the group tenuously gathered again to brave the cemetery. Would the farm appear again? Would James and Molly? Was it real? Or had the ghost stories they

told Lorry muddled their perceptions? Cautiously Michael drove in to where they had seen the apparitions. Nothing. They drove around and returned—still nothing. Scratching their heads, they asked each other if what they had seen on Halloween night was real. Only James and Molly know for sure.

# OF STONES AND BONES

*A large mushroom in its habitat.*

## MORGAN'S SWAMP

Two young hunters were tracking game at the edge of Cedar Swamp. They separated to corner a deer. One went north and the other south, intending to catch the creature in the middle to prevent its escape. As the northern hunter approached the meeting place, he saw an Indian that he felt was aiming at his friend on the southern path. Jesse fired before Gideon knew what happened.

Jesse's shot was true. Both Jesse and Gideon were excellent marksmen. Jesse killed the Indian. As Gideon ran to the sound of the gun, Jesse realized that this incident could be potential for revenge by the Indians. The Indian's name was "Morgan" and this was his territory. The Indians were already angered that the settlers disturbed the game. The settlers made so much noise when they hunted, the Indians wondered why they hadn't starved. Jesse and Gideon knew sooner or later, Morgan would be missed.

The two hunters decided that under the large rock at the other end of the swamp is where they could bury the body. The rock had a small cavern under it where Morgan lived and they determined that was where he should spend eternity. The land near the

rock was very soft and mushy. They deposited Morgan's body and his rifle there, pushing it beneath the surface of the swamp.

In later years, the tale was told with variation. Jesse told his friends he fired the shot to save Gideon and Gideon told his friends that he shot to save his friend, Jesse. To this day, the large rock with the grotto under it is called, "Indian Rock" and the swampland that borders it was known as "Morgan's Swamp." Morgan's memory lives on.

### THE HULL STREET SKELETON

As workmen of 1891 dug for a cellar hole to a new home, a skeleton was discovered. The home site was on Hull Street in Bristol. As they further excavated the hole, the skeleton of a horse was found. As the workmen continued to dig, smaller bones of a human skeleton were found but crumpled to dust when exposed to air. It was assumed that the skeleton had been buried at least a century prior.

Maybe the skeleton was one of the graves of the 1826 smallpox epidemic victims? It was known that several bodies from the epidemic were burned in a pit at the outskirts of town. With the addition of the discovery of the skeleton of a horse the determination was made that this must be Native American. A few arrows and small relics were in the grave. History does not record what happened to the skeletons or if they remain to haunt the home owner.

### WILL WARREN'S CAVE

Early in the history of Farmington, a man called Will Warren made his home in the ledges. Warren's sister was the wife of Jonathan Griswold. No one knew much about Will Warren so rumors of all kinds persisted. Maybe he was a former pirate? He seems to have preferred to spend the day with his Indian friends fishing on the Sabbath. He was publicly whipped at the whipping post on Farmington's Main Street for an undocumented offence. Will was so angry at being whipped that he set a house and barn on fire and threatened to set the village on fire. Will escaped into the mountains in the dark of night.

The Farmington people searched for Will through the fields and hills. The ever resourceful Will was chased for hours but he knew his safety would lie in the boulders of Rattlesnake Mountain. Will hid himself at one of the ledges where he could watch his pursuers. He was nearly exhausted when two local Indian women found him. The women dragged him to a hidden cavern where he remained until the searchers came and left empty handed.

Will was not found by the Farmington people but was known to pop out every now and then to frighten anyone passing his way. Many years later, a hunter saw Will Warren and his wife with their two children playing among the rocks.

In the 1870s, a skeleton was found. Could it have been Will's? No evidence of the means to start a fire was found, but those that visit Will's Cave have heard the sound of sticks rubbing together and a voice saying, "I'll get them." Could it be Will Warren or just the breezes blowing though the cairns of the mountain?

## SKELETON IN THE BEDROOM?

In an early home built on the Harwinton road near Spruce Brook the discovery was made of a skeleton. A new family had purchased the home and intended to make some renovations. The skeletal remains were found buried under the bedroom floor boards. Since no changes had been made to the home for more than a century, the skeleton must have been under the floor for some time. Surprisingly the remains appeared to be in a good state of preservation. No identifying marks, clothing or possessions were located. The apparent suspicious circumstances were considered sufficient for a Court of Enquiry.

The day came for the Court to meet to discuss the issue of the demise of the man whose skeleton was hidden under the bedroom floor. The small amount of evidence presented was not enough to determine the name of the murderer or a cause of death. Speculation was that the poor unfortunate soul may have been a peddler or wandering indigent who may have died on the property or was killed in a struggle. The name of the murderer or the name of the man whose skeleton was found was never discovered.

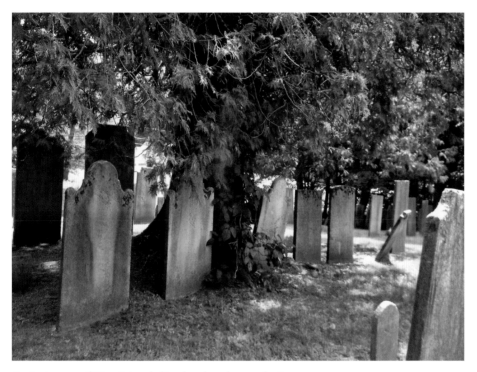

*Ancient graves of Harwinton sheltered under a large cedar tree.*

# THE LEGEND OF TODD HOLLOW

**L**OCAL LEGEND HAS IT THAT the young reverend chose this site because of its view from the top of the hill looking into the valley below. It is a forested place, not often used even by the Indians in the area. There were hills and a little stream and a generous pond with bright yellow-green lily pads. It was frequented by blue herons and egrets. Frogs could be heard in the evening and heat bugs announced the summer. It could have been a heavenly place but for the loneliness. It was devoid of humans and far off the beaten path. Sometimes, strange noises could be heard. Sometimes it was the wind, or owls, or other prowlers of the forest night. Once or twice, passers-by out too late at night noted red glowing eyes in the trees. Of course, it could just be one's imagination as the isolation could play tricks on the mind, but was it? The site was too hilly to be farm land and might be difficult for grazing. The path by the pond had huge gullies carved out by erosion exposing ancient tree roots. The gullies could be potentially treacherous places for the unobservant. It's hard to say what he expected when he made his choice to settle on the top of the hill near the pond other than it was such a pretty and pristine place, but so isolated.

A small white clapboard house with large imposing chimneys soon graced the top of the hill. It was surrounded by large, ancient maples and huge pines. It was appropriate to announce the presence of a minister. The view would be outstanding, if one could see it through the trees. It was here that the new reverend brought his young wife. She was petite with big blue eyes and masses of long blond hair. She had no idea her new husband's farm was nowhere—a far cry from the thriving port city of Boston where she had grown up. But she would dutifully try to make a life with him. After all, as they said their vows

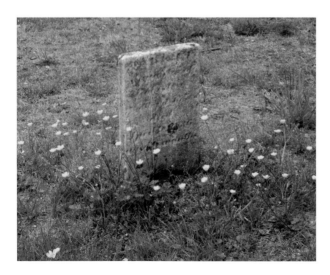

*Wildflowers mark the final resting place of a forgotten child. The inscription on the stone is too degraded to read.*

the sun shone brightly on them alone in the church. It was a good omen, everyone said so. They would be happy. She was sure of it.

Years passed, and Sarah grew tired. Five children died at birth or shortly thereafter. Sarah looked for a reason: Perhaps God was angry at them, she speculated. Perhaps they were not humble enough or observant enough. Didn't they pray together and separately numerous times daily? Didn't they cheerfully give to the church and do everything they should? What was wrong? She suspected her husband's evening wanderings. She suspected it had something to do with the Widow Simpson but that was wrong to suspect them of impropriety. It was not proper. Her husband must have a reason and it was her job to obey and not question, but—maybe it was the way he smiled at her. Maybe it was the way she smiled back! No, couldn't be. No. No! But he was there too often, too friendly, too concerned, and he stared at her too much. Why? What had she done wrong? Was this punishment? Sarah's heart was broken.

The day came of the impending birth of the sixth child. The entire congregation prayed for a safe delivery of both mother and child. Sarah and Reverend Cyrus were such a nice couple, everyone hoped for the best for them. They always helped those in need. It seemed only natural that they should be rewarded for their goodness.

The night was hot and humid when Sarah's labor began. It was a long, intense early labor. Her delivery was not expected for another two weeks. The doctor was called but would not arrive from Litchfield for hours, perhaps even tomorrow. Sarah's screams could be heard throughout the valley as the sound carried over the stillness. Hour after hour her labor continued. By nightfall, she was exhausted but still there was no birth. Cyrus suspected something was wrong but didn't know what to do. Men distanced themselves from childbirth; it was the women's realm. Perhaps the child was not in the proper position for birth—he wasn't sure.

The midwife, Mary, was young and inexperienced. Mary tried to comfort Sarah, telling her that it would all be worthwhile when she saw her child's face. It was not helping. The memories of five previous failures were firmly imprinted on Sarah's mind. Five tiny graves. Five tiny souls that would never know their mother's love. Five tiny babies that did not survive.

Darkness hung about Sarah in the candlelit room. A storm was brewing. Thunder crashed but there was no rain. It was hot. Terribly hot and humid. A humidity known only to New England like the fires of Hell itself. Hour after hour Sarah's labor continued until finally, with one horrific scream, the child was born. It was sudden—Sarah screamed, and the child died. Sarah was horrified as she slipped into a state of unconsciousness. Cyrus ran out, down the path to the Widow Simpson. He had found a friend in her and in this time of crisis, he needed her desperately.

Mary wrapped the infant carefully and placed him in his cradle to wait for Cyrus to return. Mary remained with Sarah but soon fell asleep. It must have been near midnight.

Cyrus did not return. Sarah awoke alone, delirious in fever. She stumbled to the tiny cradle to find her fear was true, the child was dead. In her state of feverish exhaustion she grabbed the child and began running out the door. Mary stirred only slightly when Sarah slammed of the door. Thunder crashed. Lightening darted about in an evil dance to light the path. Sarah knew who to blame and maybe if she could catch them together, God would forgive her and her child would be alive! Nothing would stop her this time and she had to catch them! She grabbed up her skirts, clumsily thumping down the path. It was awkward but she had no time to lose. Voices in her head told her to hurry. Time was slipping by. Sarah stopped long enough to clasp her head. It hurt. It throbbed and the voices got louder and louder, telling her to hurry. Catching the Widow and Cyrus would save her baby! The child's life was slipping away. She had to run and run as fast as she could!

As she neared the pond, lightning struck a nearby tree. She hugged the child tighter and ducked, as if ducking would make a difference to the crashing storm hovering about her. A loud crackle and crunching of a tree broken by a lightning strike added to the creepiness of the stormy night. The pond glowed like an evil being swaying in the night. Sarah stumbled, clutching the child, protecting it from the night with her body. She rolled several times, then blacked out. Heavy winds whistled angrily through the darkened forest. Even the creatures of the night were not visible as they also hid from the onslaught. Lightning struck nearby again. Sarah stumbled forward and fell into a deep hollow formed by the centuries of water currents and the ancient roots of a gnarled old willow tree.

It was early morning and the storm had abated. The sun was not yet up. The air had cooled but hung like wet laundry. Mary was in a panic—Sarah and the child were nowhere to be found. Cyrus was returning home as the storm subsided and stumbled into Mary. Mary babbled hysterically the story of the birth, the fever, the screaming, the storms and a tangled tale of Sarah running out of the house. It made no sense. Cyrus grabbed Mary and shook her, trying to bring sense to the story. Mary kept babbling and crying. Cyrus stomped off to search for his wife.

Poor Cyrus never found his wife and child. The entire village came out to help with the search. They shouted and called for hours—days and weeks went by. Sarah was never found. The searchers eventually gave up. Cyrus never recovered. He blamed himself. He blamed his dishonesty. He blamed his misguided sense of loyalty to his congregation for the loss of his wife and children. As the years went by, he became more and more crazed. He talked to himself, the trees, the roots of the trees, animals passing by, the wind and the rain. He would ask if they had seen his wife. He would yell at them when he got no reply. He became angry that no one would tell him what happened—they could not, no one knew what happened, but Cyrus no longer understood reason or anything about the everyday world. Finally, in the darkness of his closed mind, Cyrus wandered off. It was the same search as before, villagers calling, looking everywhere, shouting his name. He never answered.

*A brook at Todd Hollow.*

The old house still stands on the lonely hill. Whistling sounds in the valley are suspected to be ghosts. Are they still there? Is Sarah looking to claim a soul to save her child? Or is Cyrus still searching for his wife and child?

Others came to the homestead and went, but no one stayed. Stories persisted about an evil presence haunting the valley. A child's coffin was found many years later hidden in the cellar. Why? Josiah's child drowned in the brook, as did Elijah at only twelve years old. Something dark hung over the valley and to this day the whispers continue. Could it be a presence? Or is the silence of the valley haunting enough?

# THE GHOST DOG OF TOWN HILL

IN THE EARLY DAYS, BEFORE the real roads were created and there were trails difficult for even the best horse, a Ghost Dog existed. It was along Town Hill, the part that later became the extension of the main road, near the large granite boulder on the right, that he would wait. The trail was dark, even in the full moon, because the foliage was so dense, with trees so huge they created a tunnel that no light could penetrate. It was always night.

The Ghost Dog would spring past any poor wandering soul happening to pass that way, just as he nearly reached the boulder. There was no growl, sound, or snarl—he was entirely silent, just a ghostly apparition passing with lightning speed in front of our traveler and his horse. The Ghost Dog, as quickly as he sprang out, disappeared into the heavy foliage on the other side of the road. Again, without a sound, no rustling of twigs, breaking of branches or crunching of leaves.

The light of morning could not bring a trace of our dog. No disturbance in the leaves, no bracken nor bush pressed hard by the landing of our Ghost Dog; absolutely no trace could be found. The mystery of the lack of presence of the Ghost Dog was as frightening as his appearance. No rhyme or reason could be given for when to expect him. Neither travelers with too much drink or the sober preacher could know when to expect a visit on the trail by the Ghost Dog.

Only this much of his story is known, and its origins date back to pre-colonial times. Possibly our Native American friends knew the dog when he lived, but his chase continues into eternity as his poor lost soul continues to wander. This place is still avoided by even the bravest of travelers who know the story of the Ghost Dog. None dare to challenge his presence, for it is not known if he is driven by an evil intent, he is atoning for some past error or if he is just doomed to chase his quarry forever. We will never know.

The Ghost Dog is still there, on the trail, waiting for a lone traveler to pass. If he happens to cross your path in the dark of the trail, forgive him; perhaps this forgiveness will free him to find his eternal rest.

# WHO WAS THE LEATHERMAN?

THE LEATHERMAN WAS A LONELY wanderer of Connecticut and New York. Some say he was the lovelorn Jules Bourglay who lost the fortune of his fiancé and then lost her as well. The story is false, but prolific and in spite of numerous efforts to dispel it, the myth continues. The basis comes from a story published in 1884 that was later retracted as purely fictitious.

The Leatherman's story begins about the year 1856 when a mysterious man dressed all in leather garments first appeared in the Harwinton, Connecticut, area. He travelled on foot in a circular route of 360 miles accomplished in exactly in 34 days. The route took him through Danbury area, Watertown, Middletown and the Connecticut River Valley towns, into Westchester County, New York, in a clockwise circle. He made his home in various caves, including Tories Den in Burlington, Jack's Cave in Terryville, and Black Rock,

Thomaston and others along the way. He was known to have small, carefully maintained gardens at some of his stopping sites. Each regular stop contained preserved scraps of meat, apples, nuts, berries and extra leather bits with which to mend his suit. His cave was always prepared with firewood for his return.

He was a gentle soul that did not beg or do harm to anyone. He rarely spoke but it has been suggested he may have understood French. After his death his only possession was a French prayer book. His suit of stitched pieces of leather did not change over the years but was carefully patched as needed. It consisted of a long coat with numerous pockets inside and out. He made his boots from spruce wood and leather. The outfit was completed with a cap and leather pack. He was fond of tobacco whenever it was possible to obtain. He appeared to be about five feet seven inches tall with black hair and blue-grey eyes.

His route was regular and after a time he would stop at some homes along the way. Not all, just a few carefully selected homes. These homes would leave a plate of food outside for him. It became an honor to be one of the farms the Leatherman had chosen. One local teacher promised that the student with the highest grade could present his or her gift to the Leatherman. Each child, on the day of the Leatherman's expected arrival, brought a small gift for him, but only the child with the highest grade was permitted to step forward and personally present their gift.

An incident took place in Forestville, Connecticut. Locals were determined to get the Leatherman to speak. They tried to get him drunk. The revelry subsided and the unsuccessful drunken group tossed the Leatherman into a horse trough. Could cruelty be the reason for his silence? Was he autistic, or was it self-imposed as penance for some act he felt was unforgivable? Did he not understand English? Or maybe was he unable to speak for other reasons?

The silent but resourceful wanderer may have learned his outdoorsman ways as a Native American, or because he was homeless his ways were learned for survival. His story comes to an end in March of 1889. His remains were found in his shelter at Mt. Pleasant, New York. Our poor soul died of cancer at approximately 50 years old. He had survived the infamous Blizzard of 1888, losing only four days of his meticulous self-imposed time schedule, only to die a year later of cancer of the jaw.

Some claim to have seen him since the day his body was discovered. He still follows his schedule, stopping by his caves along the way. He maintains his earthly journey dressed in a spiritual suit of patched leather, perhaps continuing his penance in the afterlife for sins of his earthly life.

In 2011, an archeological dig attempted to exhume the Leatherman's grave to look for his bones. It was hoped to find sufficient skeletal matter to attempt a DNA match. Unfortunately, only a few coffin nails were found, but no bones. Apparently, even in death he retains his silence and the secret of his identity. Therefore, we remember him as the singular soul who never hurt anyone as he traveled throughout the Connecticut and Hudson River region and into history.

# ANCIENT MILESTONE MARKER

I N 1835, A HIGHWAY MILE marker to Hartford was placed on Main Street, near the present Bristol town line, signifying that Route 6 was once a well-traveled roadway. The markers were used to specify the distance from the marker's location to Hartford and Litchfield. The surviving markers are evidence of earlier transportation networks whose history is frequently lost with the passage of time.

This marker is made of dark brown stone and looks a bit like an old tombstone. It is roughly carved and very weathered. It is inscribed:

<div align="center">

19 Miles to Hartford

13 Miles to Litchfield

1835

</div>

The date of 1835 is confusing as other records state that the marker was placed in 1815, just a few short years after the incorporation of the Town of Plymouth. It is indication of the growth of the area as the town and the fledgling United States expanded.

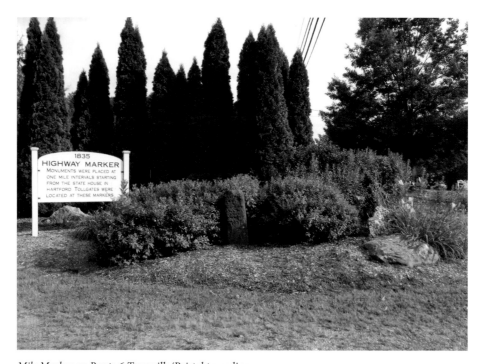

*Mile Marker on Route 6 Terryville/Bristol town line.*

Some markers in other towns have only a numeral inscribed designating the distance from one town to the next. It could imply that the traveler may have known where he was going and where he had been. Considering the rural spaces between towns and civilization of early Connecticut, it certainly seems that one might not have known the specific distances between major cities and towns.

# THE GREEN LADY~OR NOT?

THE LEGEND OF A GHOSTLY woman appearing by the ancient Seventh Day Baptist Society burying ground of Burlington has proliferated for more than a century. The legend says that Elisabeth Palimeter died in a blizzard by falling into the waters of the brook near her home in the vicinity of the cemetery. Some say she was in search of her philandering husband, while others say she is angry and chases anyone who comes to the site with a ghostly hatchet by the light of a full moon. She has been noted to appear, smile and disappear. Legend says she appears as a green mist, or as a beautiful woman in a green ball gown, and wanders down the road to disappear. Another legend warns of a phantom caretaker of the cemetery chasing away anyone who dares to venture near it.

The most common story is that she wandered out on a stormy night in search of her husband and fell into the swamp and drowned. Maybe she drowned by the hand of her husband if he had eyes for another woman. Old New England did not permit divorce any more than it permitted witches, so his only recourse would be to eliminate wife number one. Of course, there is no specific record other than Mr. Palimeter remarried after Elizabeth's death. It is also possible she may have fallen into the water on her way to the outhouse, or died by one of the numerous epidemics of the times. No one knows for sure.

The legend has no basis in recorded fact. Elisabeth was the wife of Benjamin Palimeter. She died April 12, 1800. Benjamin later married Anstis, who died in 1859 at 88 years old. Benjamin was 82 at the time of his death June 2, 1850. He and Anstis had one child that died young. There is no record that Elisabeth met an untimely death accidental or at the hands of Benjamin. It is the eerie isolated location of the cemetery which makes it fertile ground for legends.

The ancient tree-lined dirt road itself could be as guilty of fermenting legend as those who make them up. During the 1930s, a fresh air camp for city children was in the neighborhood. Camp counselors were fond of making up ghost stories and the isolated woodland with a mysterious cemetery nearby made a perfect setting. The very remoteness of the site certainly provides much fodder for vivid imaginations.

*The gate at the Seventh Day Baptist Cemetery.*

Today, its real history is just a memory. The road is nearly forgotten. It is gloomy and foreboding. As one drives down the road, convinced they are passing into the next life, a misty brook becomes visible alongside the road. The road then opens to huge old trees and a stone wall that encloses the ancient grounds of the abandoned cemetery. The Seventh Day Baptist Burying Ground has been decimated by vandals. Nearly all the gravestones are totally gone—a few stumps of gravestones are all that remain.

It is a sad, quiet place with the appearance that time has stopped. It is a small plot with two dozen or so small stones. The large, elegant maples that were most likely there in Elisabeth's time remain silent still. The ground is covered with green mosses and soft grasses. A few wildflowers peek out from nearby stones here and there. The stillness can make one imagine the presence of the people that once lived here and tended these graves. The small entry has two granite posts for a gate that opened just wide enough to carry a pine coffin to its final resting place. The feeling is sadness or maybe the earth is holding its breath. Nothing is moving but an occasional haunting breeze. It is a vision of the past not yet lost to progress.

*The Cemetery of the Seventh Day Baptists of Burlington. Vandalism over the years has destroyed nearly all the grave markers, and only small bits of rock remain.*

# THE GHOSTS OF
# LAMSON CORNERS

A LONG ROUTE 69 IN A remote section of old Burlington is a cemetery called "Lamson Corners Cemetery." This part of town was once known as "Polkville," named after President James K. Polk, who was president from 1845 to 1849. The cemetery is located in a place of isolation, on top of a hill. The original entrance to the cemetery has been blocked off to vehicles and a secondary entrance has a precarious climb up the hillside. Most cemeteries give off vibes of peace and are quiet places of seclusion, birds, and wildlife. Lamson Corners gives a sense of foreboding and waiting, as if something is about to happen. Could it be from residual energy from the past?

Route 69 is patrolled by Connecticut State Police but that is the only view of present day. There are no power lines or underground wires to create unusual sounds or conflict with electronic equipment. Yet upon walking to the top of the hill, the feeling is ominous. Sometimes a mist floats on the small swampy pond nearby. Maybe the mists are from the pond—or maybe they're from something else.

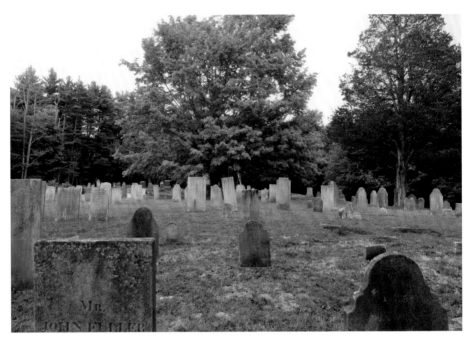

*The graves at Lamson Corners Cemetery on a quiet afternoon.*

Lamson Corner dates from the first burial in 1783 and is still occasionally used today. In colonial times, epidemics were common. An epidemic ravaged the area in 1809 and again in 1825, with others following every few years. Children were frequently victims. Mortality was ever present and close at hand. Vaccination for disease was only in its infancy. Antibiotics didn't exist. Children and adults died from Diphtheria, Smallpox, Pneumonia, Influenza, Measles and Consumption (Tuberculosis). Death in childbirth was all too common for women. Men usually died of illness, accident or war. Statistics of infant mortality were very high. Death was an ever-present reality.

Visitors to Lamson Corners claim to have seen red glowing orbs, a woman in a lacy Victorian wedding dress, or a ghostly soldier. Men with top hats, canes and elegant jackets with lace sleeves and women with flowing satin dresses, parasols and gloves of Victorian days are seen going about their day as if time stopped during their generation. An occasional spectral horse and buggy have been seen passing by.

The most famous of the unearthly visitors has been the Green Lady, possibly on a ghostly vacation from her usual haunt at the Seventh Day Baptist Cemetery, and a hitchhiker named "Abigail" haunts the highway. Perhaps it is the remoteness of the area in general that leads people to wandering visions. Could it be the elegant old trees creating a glimpse into Lamson Corner's ancient past?

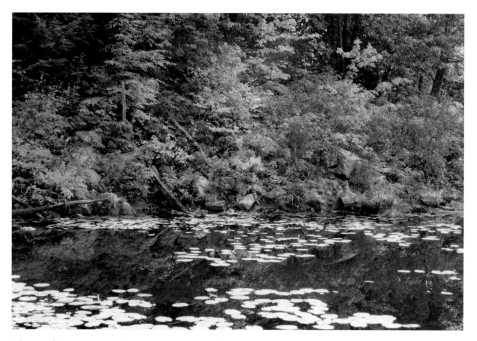

*The pond near Lamson Corners Cemetery with spooky mist creeping through the rocks and trees.*

So if you are ever passing through Route 69 into Burlington or Bristol and a young woman smiles and asks for a ride, it could be the Green Lady, or Abigail. The best choice is to keep going, lest you become one of the ghosts of Lamson Corners!

# THE MYSTERIOUS TALE OF THE OLD LEAD MINE

T HE STORY BEGINS IN 1657, when John Stanley and John Andrews ventured from Farming Town, as Farmington was then known, into the wilderness of the Naugatuck Valley. Upon their return, along with delightful tales of the charming valley, was a large piece of black lead. The source of this treasure was not recorded, leaving its true location the subject of a great many discussions and the subject of dispute. The expedition of Stanley and Andrews's find of lead sparked great interest. Soon a land deed

*An isolated pond at Poland's River.*

was procured from the Tunxis Indians for the suspected source of this fine black lead and all the land within an eight-mile radius around the potential location.

Of course, with no record of which hill or any identifiable landmarks or notable features near the black lead site, it would be impossible to locate it again. This concept evidently did not occur to our early adventurers. The story of black lead site became bigger and bigger and more important as time passed. The United States of America was yet to be formed and minerals were sorely needed. Exploration teams were formed to search for the infamous lead deposit. The party was divided into three groups. One group was led by the Reverend Samuel J. Mills of Torrington, another by Reverend Andrew Storrs of Northbury (later known as Plymouth) and the third group led by Reverend Samuel Newell of New Cambridge (later known as Bristol). Each group was led their local minister—surely this would bring good fortune! It was decided that a bell was to be rung to notify other groups when the mine was located. There was no doubt that they would be successful. The search continued for three days until well after dark each day. Finally, the search was abandoned. There was no need for the bell as the mysterious lead mine remained hidden.

The enigmatic lead mine continued in local lore. Another legend states that a hunter came across a large piece of lead and attempted to carry it home on his shoulders. He had not gone far when he was seized by the hand of the Devil himself. He claimed to have been knocked unconscious by a mysterious hand and when he awoke, his treasure was gone. He returned home empty-handed. In order to explain his lengthy absence, he

claimed the "invisible hand" smote him and stole his treasure. The mysterious lead had eluded capture again.

Some early maps mark potential sites for the mine, but upon further research, no trace of mining operations was ever found. During the French and Indian War (1754-1763), another resident claimed to have found a large outcropping of lead. He was adamant he found enough lead to make much needed bullets for muskets. Yet upon return, the out-cropping was gone. The man was befuddled—where had it gone? Did he ever really find it?

In the times of the Revolutionary War, a local British sympathizer, Captain Moses Dunbar, while hiding from the ever-present and resourceful Sons of Liberty, found a cave with a large vein of lead. He bragged that the cave had enough lead to make bullets for the King's armies to defeat the unruly colonists. Captain Dunbar never had a chance to return to the cave. He was captured by the Sons of Liberty and imprisoned in Hartford Jail. He was tried for treason against the newly forming nation and hung as a traitor to the colonies in Hartford in March 1777.

So where was the elusive lead mine? Did it really contain lead that could be used for musket balls or was it graphite used for pencils? Was it guarded by mischievous spirits? Or was it just a question of finding the proper location? Even with the aid of fortune tellers and diviners, the source of the lead mine as referred to by Mr. Stanley and Mr. Andrews was never found. Did it ever exist or was it a legend that grew over the years? Today, even with all the land development of the last few centuries, the site is still undiscovered. Perhaps we will never know.

# TRIAL BY GOSSIP

WITCH TRIALS ARE PART OF human history. As early as 2250 BC, Hammurabi spelled out what happens if spells are cast and the power of the earliest superstitions of witches and demons are used or suspected. The connection always seemed to be how to define the unseen and the scientific truths of life that were not available until much later in history. Cultures and deviation from accepted social norms could be fatal. The most famous example, other than Salem, Massachusetts, was Wurzburg, Germany, during the years of 1623 to 1631. Julius Echter von Mespelbrunn, Prince Bishop of Wurzburg, and Philipp Adolf von Ehrenberg were responsible for the burning of 900 persons, the majority of which were women, and some were children. So many women were killed in Wurzburg that no women were available for marriage. It has been estimated in Europe that nearly 80,000 were executed as witches; the majority were women from the years of 1500 to 1660. Trials continued throughout the 16th and 17th centuries.

Witchcraft was very much a part of the culture when the Pilgrims came to the New World. Under the reign of Charles I of England, persecutions for witches increased. This was the time of the Pilgrims. Their world was a fearful place. Frightening journeys across the Atlantic and the discovery of places with strange new people, animals, plants and strict religious beliefs offered no consolation, only fear.

To be accused as a witch, it took as little as gossip. The death of a child, livestock or a misunderstood tragedy could be sufficient to be accused. Accusations could also come from feuding neighbors, rumors, or arguments between husbands and wives. There also could be a property dispute. Should someone be indicted as a witch, their property was confiscated. The property could then be sold, possibly even sold to the person making the accusation. The bottom line was that it was easy to be called before the magistrate for witchcraft. It was a frighteningly real possibility. The fear of witches and conjuring by a witch followed the Pilgrims across the ocean.

Alse Young was first to be executed in Connecticut in the year 1647. She was accused of witchcraft and blamed for an epidemic in the town of Windsor. Alse became the scapegoat for the community's fears. Little is known of Alse. She may have been the wife of John Young, who owned a small farm in Windsor. Alise's daughter, Alice Young Beamon, would later be accused of witchcraft in Springfield, Massachusetts—she was tried because her mother was an executed witch. The trials continued. Mary Johnson, Joan and John Carrington, Goody Basset and Goody Knapp were all executed as Connecticut witches.

The Carrington's had four children at the time. The oldest, John Jr., is believed to have lived in Waterbury. The indictment of John Carrington read as follows:

> John Carrington thou are indited by the name of John Carrington of Wethersfield, carpenter, that not having the feare of God before thine eyes thou has Intereined familiarity with Satan the great enemy of God and mankind and by his help has done works above the course of nature for w*h both according to the Law of God and the Established Law of this Commonwealth thou deserves to dye.
>
>       Indictment of John Carrington. The same language was used for John's wife, Joan.
>                     (Spelling was not standardized at this point in history)

John and Joan were indicted by the Particular Court of Hartford on 20 February, 1650. The accusation that brought them to court was "familiarity with Satan." It's hard today to understand what that meant to early Connecticut citizens but it was certainly sufficient to cause one to be accused of witchcraft. John was a carpenter and had been brought before the courts for selling a gun to an Indian—possibly his legal troubles were the source of his easy conviction. His wife was guilty by association. Later, in Springfield, Massachusetts, Hugh Parsons was accused of witchcraft by his wife because he was sympathetic to the Carringtons.

Little is known of the Carrington family or what happened to the other Carrington

children. Possibly for their own protection, their names were changed. Young John was about fourteen at the time of his parents' executions.

The jury that found the Carringtons guilty included local famous men such as Thomas Judd, William Lewis and Stephen Heart. The court ordered that the property of John Senior be inventoried and filed in Mattatuck Plantation courts in Waterbury. The record of the estate and its inventory has not been located. It is truly sad to think that is was so easy for someone to be destroyed financially by court and prison costs and to incur the maximum penalty of death for what we know today as false acts relayed by means of gossip.

# GOODY NORTON AND THE TRIAL BY WATER

Every old woman with a wrinkled face, a furr'd brow, a hairy lip, a gobbler tooth, a squint eye. Squeaking voice, or a scolding tongue … a dog or cat by her side, is not only suspected but pronounced for a witch.

Seventeenth century English clergyman John Gaule

LIFE IN THE EARLY CONNECTICUT wilderness could be dangerous. Wolves, bears, wild animals and Indians prowled the woods. The severe winters, floods, epidemics, natural disasters and witches incited fear in the hearts of families. Puritanical religious beliefs offered no solace. Religion required strict piety in order to please God and demonstrate one's worthiness. Any form of evil, real or perceived, was not to be tolerated and that included witches.

When the first Pilgrims arrived at Plymouth Rock, witch trials were common in Europe. The trials predominately claimed women, but children and even men could be accused as witches. Some European villages executed so many witches that there were no women left in the community. The belief in witches was partly religious, partly ignorance and even based on socio-economic classes. An unmarried woman was suspect, a healer, an independent woman, a poor widow—any woman could be a witch. Women were expected to marry, maintain the home, bear children and be silent. Exceptions could prove deadly. Witches in Europe were often burned at the stake as a public spectacle.

The definition of a witch could be that of the strange lady with a cat next door, or the elderly widow that talked to herself as she walked through town. It could be someone that was just a bit odd, didn't follow religious expectations, never married or did not attend

*River land leading to Dunking Pond.*

church, or even if she looked too long at the minister's son instead of listening to the sermon. It was possible she was an herbalist or healer but if one of her treatments failed, she could be accused of being a witch. Maybe it was the man on the next farm who spent Sunday with a sick cow rather than attending services. An accusation of spectral evidence could be damning. Spectral evidence is the claim that a person is being tormented by an image or vision of a specific person. That image was believed to have been a real person using witchcraft to harm her victim. Anything outside of the very rigid rules of society could be grounds for being called before the magistrate to explain your motives. Witchcraft was a capital crime until 1715 in Connecticut, but not before at least ten were executed. Between 1642 and 1693, approximately 40 were accused in Connecticut, and after that the accusations slowed.

Goody Norton claimed her aunt would put a horse bridle on her and ride her to the witch meetings in Albany. Neighbors were horrified by Ms. Norton. Very soon Goody Norton was labeled a witch. The year was 1768 and Connecticut and Salem witch trials were recent memories. Torture, incessant questioning lasting days and the water test were tools used by the inquisitors.

The accused witch would be called on to explain herself, though it rarely did any good. The drums would beat to announce that a town meeting was to be held. The witch would be tried publicly. The water test was a favorite of inquisitors. A long, lever-like structure was made like a child's seesaw. It had a seat at one end and a handle at the other. The

witch's left hand was tied to her right toe and her right hand tied to her left toe and then she was tied to the seat. She would be repeatedly dunked in water. The theory was that if she had renounced her baptism and joined with the devil, the water would reject her. If she happened to drown, she was innocent as the water accepted her. If she lived, she was a witch and tried accordingly.

Goody Norton was scheduled for the Trial by Water. Early in the morning, the rumbling of the sheriff's prisoner cart could be heard on its way to the home of Goody Norton. The prisoner's cart and spectators stopped at the Norton home.

The sheriff knocked at the door and called, "Bring out the witch." No one answered the door. He called again, "Bring out the witch."

Again, no answer. Finally, he had had enough. The dunking stool was prepared and the water at Indian Heaven pond was selected. Everyone was waiting, but the witch did not appear. The sheriff entered the home and no one was there. He searched the loft, root cellar and the barn to no avail.

No trace of Goody Norton was ever found. There is no record of what happened to Goody Norton. Was she executed and it was not recorded? Perhaps drowned when dunked? Maybe her family sent her away in the night to save her life or possibly she was confined as insane and lost to history. The records do not give any answers, but she is the last recorded witch in Bristol, and the mystery of her fate continues.

*Notice the distant trees with the mist covered rocks. Above the center rock is a shape of a woman. Could it be Goody Norton coming back to visit her old home or her old neighbors?*

# THINGS THAT GO BUMP IN THE NIGHT

### THE WITCH ROCK

Along a path between Bristol and Terryville is a place called the Witch Rock. It was so named by Elijah Gaylord. Mr. Gaylord lived at the edge of Fall Mountain. Every time he returned from church and passed the Witch Rock, the yoke of his ox cart mysteriously fell out of place. It dropped from its hitch, leaving him stranded as his oxen slowly made their way home—without Elijah.

Because it happened each and every time at precisely the same place, it was decided that the rock was possessed of a spell cast by witches. The name "Witches Rock" stuck to the place where Elijah Gaylord's ox cart always dropped its yoke.

### ELDER WILDMAN'S HOT PINS

In another instance of affliction by witches, a young woman was terribly tormented. She was afflicted with hot burning pins. So terrible was the suffering of the child that the elders of the church were called. A man named King was the assistant to Elder Wildman and seemed to be present at all of the instances attributed to witchcraft. Many tried to help the child. After lengthy consultations and observation by church members, Elder Wildman was personally called in. He brought another assistant but the assistant went into convulsions. Another was called, but the same thing happened. Mr. King was present each time but it had to be something demonic. Elder Wildman wanted to help the child but no one else would volunteer to assist. All were too afraid.

Elder Wildman took a seat by the child and spoke gently. He took out a silk cloth. He carefully removed each hot pin and inserted it into the silk. Finally, when all the pins had been removed, he held the cloth over hot coals. The heat from the fire consumed the pins and the young girl was never again so afflicted. Mr. King left shortly after this instance and the episodes of evil spirits and witches ceased.

### THE TROLL UNDER THE HARWINTON ROAD

Mr. Sutliff had heard that gold could be found near the Harwinton Road. He expected that the gold and silver would be so easy to find that he could scoop it up with a ladle. As he dug, in order to avoid various large rocks, his route became very circuitous. Day after day as wagons passed, repeated banging noises frightened everyone. People were suspicious of strange noises. It took time for New Englanders to understand what was real and what was imaginary. Rumors spread that a troll lived under the road. The troll was reputed to be making the sounds in expectation of payment for successful passage.

Soon travelers and neighbors left offerings of food for the troll in hopes of safe travel. Mr. Sutliff thought his neighbors were very kind to supplement his meager diet. He had no intention of sharing his bounty once discovered, but naively thought it was nice to know his neighbors could be so kind. He continued digging, day after day. Nothing was discovered, but he continued, well fed, but as yet empty handed.

Finally, a traveler decided to see what was under the road causing the noises. He did not bring an offering for the troll so he figured he might as well confront the troll first hand. He crawled into the tunnels. After an hour he was ready to give up until he came face to face with a very angry, dirty Mr. Sutliff, looking very much like a troll. The two stared at each other. The traveler was terrified as he slowly backed up. Mr. Sutliff certainly cut a frightening picture with mud stuck to his hair, disheveled and dirty!

The traveler backed out of the tunnels in terror. He ran all the way to the nearest tavern in a sweat. When asked about his distress, he stated that he had met the troll under the road and that it truly was a frightening spectacle. He warned that they must keep up their offerings and never enter the tunnels for fear the troll would eat them, especially if he was very hungry.

Mr. Sutliff heard of the traveler's tale and was very pleased with himself. He went back to digging, knowing that he could continue his excavations in peace with lots of good food. He never did discover gold.

## THE CHAPEL GHOST

A small chapel that began its days as a Sunday school on Chippens Hill, near the favorite trail of an Indian named Shum, is reputed to be haunted. The Sunday school was organized in 1884 for children living too far away to attend church. The chapel was named Mount Hope. Frequently ministers of various denominations were called to speak as well as other noted speakers of the day. It existed as a non-sectarian Sunday School for many years. The school supported a missionary pastor at Mount Hope School in India. His reports were shared with the Sunday school regularly.

Eventually, in the 1960s, the chapel became a spiritualist church. This pretty little building has been known to have a ghostly image of a man seen in its bell tower. It is reputed to be the ghost of a former parishioner who was stuck by lightening on the church steps. Although there is no record of such an event, the story continues. Others maintain that spirit orbs float around the building. There is a stillness at the site that makes one wonder if the hauntings are true, or truly imaginary.

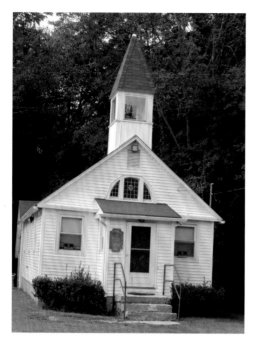

*Mt. Hope Chapel.*

# THE ASCENSION OF ASHAEL (WELL, MAYBE)

**A**SHAEL WAS A LITTLE PECULIAR. He took life very literally. A misguided group of followers of a man claiming to be a prophet hoped to establish a community on Ashael's vast property in Bristol. The prophet was named Frederick Howland, a former dentist who found prophecy far more profitable that dentistry. Mr. Howland claimed he could raise the dead and that he personally was the Holy Ghost.

Ashael, even after Howland left the area, still believed that in 1843 the Holy Ghost in the form of Howland would come and claim his own to ascend to Heaven. Ashael thoroughly cleaned his home and donned his ascension garments. He climbed the giant pine tree in front of his home with a pole that was used to raise and lower the bucket on his well. The pole is known as a "well sweep." He waited and waited, prepared for the Lord's coming. He waited all day and half the night, but it was not his time. Eventually he climbed down from the pine tree but forgot his well sweep. Many years later the tree was blown down in a storm—with the well sweep still lodged in the fork of the tree. Whatever his intentions were for the well sweep is not known. Ashael never disclosed his reasoning, probably too embarrassed to admit he believed a charlatan.

# THE SPIRIT FOLLOWER OF PECK LANE

A S THE SPOOKS AND SPIRITS of New Cambridge tormented its people, so did one on the hill known as Peck Lane. It was late one night in 1822 when a young woman named Stiles was walking home from visiting a neighbor on the hill. A short time after she left, the family heard frightening moans outside their door. The same woman was on their door step, barely conscious. She was brought into the house and medical aid was called. Her condition did not improve. She was carried to her home where she died.

An autopsy was done. The medical experts determined she had been grievously assaulted by demons in human form. Efforts were made to locate the criminals but they were never found. Not long after Miss Stiles was laid to rest, anyone who came up Peck Lane after dark near the site where she was assaulted would be followed by a light. The light would keep pace with the passerby then turn eastward toward the home of Miss Stiles. The timid stopped using the lane after dark. Was it Miss Stiles escorting travelers past the site of her assault, or was it the demons looking for additional victims?

# THE FORGOTTEN WITCH

C ULTS, MYSTICS, SNAKE OIL SALESMEN, demonic possession and witches have long been part of our history, and this part of Connecticut is no exception. The Wakeman Cult and its "Divine Messenger" Rhoda Wakeman have been all but forgotten, but a legend survives. Rhoda Wakeman claimed she had been murdered by her husband and died. While dead she said she toured Heaven and been given the divine mission to heal the sick and raise the dead. She said her fate would be the fate of the world—as long as she lived, the world was safe. Therefore, Rhoda determined that she alone could save the world. She was considered a witch by her neighbors. They avoided her as they believed she could cast spells and harm them, their families or their livestock. It was rumored that she bewitched her husband and caused his death. Neighbors were very afraid of the 70-something occultist widow.

Rhoda was a woman who truly believed it was her mission on earth to save the world—her way. She gathered a small flock of believers. Only a few names survive in the history books, and the rest are mercifully forgotten. Her following included Justus Matthews of Bristol, his wife, the

sister of Justus and her husband and a confused little man named Sam Sly. As Rhoda preached, her little group hung on her every word, truly accepting she was divinely sent as a messenger.

After a time, Justus was slipping away from the cult. His wife was intent on remaining in the cult but Mr. Matthews found other things to do. He got into mischief. Instead of attending Rhoda's mandatory meetings, he was out playing cards, chasing women (those that allowed him to chase them) and frequenting the local taverns. He had loaned Rhoda money with the full expectation that she would repay it. Rhoda was not pleased. Not only did Justus stray from the flock but he failed to understand that she was far too important to the world to trifle with little earthly things like loan repayment. How dare he not submit to her machinations! She believed Justus must be inhabited by a demon. Freedom from demons and salvation could only be achieved by following the chosen one, and Rhoda decided she was the chosen one.

Rhoda began to gear her sermons to rail against sinners and in particular anyone that strayed from her flock. She targeted Justus. She decided Justus wasn't following the proper path and the entire world was at risk because of him. Finally, Rhoda had enough. Nothing she said to the flock, to Justus or his wife seemed to bring him back into the fold. Rhoda's next sermon was that in order to save the world and of course, avoid repayment of the loan, Justus had to be sacrificed. Justus, for whatever reason, agreed. Maybe he didn't expect the consequences to be quite as severe. Perhaps he felt it was his duty, or he gave in to his wife, or the cult or maybe he just gave up. We will never know his motives, only that he became a willing participant in Rhoda's plan.

Rhoda had no intention of repaying her debt, and therefore, she believed, Justus had to be brought into line. She conveniently determined that Justus was possessed by demons. She was adamant Justus had to die to exorcise the demons that put Rhoda, and therefore the world, at risk. The cult eagerly followed her every word, not thinking Widow Wakeman could have other motives. The winter full moon was selected as the proper time. It was cold and the weather was angry in preparation for winter, but the cult gathered.

The little party walked somberly to the Wakeman cottage. Although it was dark, the moon brightly lit their path. Rhoda Wakeman said the full moon was a good omen, not willing to pass up any opportunity to show off her divine status. Arriving at the cottage, Justus entered first, then Rhoda and the rest of the group. Sam Sly was last. Sam needed to get behind Justus. Sam had specially selected a witch hazel branch. Witch hazel was the perfect tool, as it was considered the best tool for driving out demons. Sam Sly was ready.

A chair was brought out for Justus. His sister bound his hands and tied him to the chair. Rhoda tied a black silk kerchief over his eyes. Black silk was best to prevent Justus from enchanting others with his evil stare. Rhoda swayed and howled. The cult roared chants. Sam swung his witch hazel bat repeatedly at Justus. When beating Justus didn't kill him, Sam took out his knife and stabbed him. The gruesome deed was finally done.

The cultists walked around and around the sacrificial body, still chanting and giving thanks that Rhoda was safe and the world was saved. The members of the cult were relieved.

Their mission was successful, at least until local authorities heard about it. It wasn't long before questions arose concerning the disappearance of Justus Matthews. Rhoda was arrested first, then the rest of the cult. The judge and jury determined it was murder. The Wakeman cult was dissolved. Each of the participants would spent the rest of their days in prison. Now the world was safe!

# THE PENNSYLVANIA HERMIT

**M**R. SHELDON MAY HAVE BEEN the unluckiest man on earth, or at least in New Cambridge. Poor Mr. Sheldon purchased land in Pennsylvania but he did not inspect it before buying it. He believed that it was a good deal for the price and used all of his life savings for the purchase, sight unseen. Of course, his wife wasn't too happy about the deal so he went on to his new farm in the country alone. He couldn't understand her reluctance at such a bargain but was sure she would love it once he created a home for them.

Roads were unpleasant affairs in the early 1800s. They were muddy with large ruts. Roads were often made by laying poles long ways across the road as a way to stay out of the mud or the ruts. Such roads were called "corduroy roads" because of the similarity to corduroy fabric. It was nearly a month before Mr. Sheldon reached his land. He didn't understand why the men at the General Store were laughing so hard and slapping him on the back. Maybe it was a country thing—after all, he came from New Cambridge, and that was settled in comparison.

He carefully followed the directions to his land, further and further into dark, dreary woods. After a few hours, the sun was nearly ready to set. The woodlands opened into what should have been meadowlands bordered by a gentle river, grazing lands and water. Mr. Sheldon had thought it was such a good deal when he purchased the land. Then, as he continued down the trail, things didn't look right. Doubts were entering his mind. Nothing was as it should be. The supposed meadowlands were brown. This should not be with a water source so near. The gentle river was really a raging torrent washing out everything in its path. Trees had been uprooted, and nothing had a chance to grow after the spring rains. The brown grasses were mixed with mud and more rocks than he had ever seen in one place. The only place to spend the night was the cave on the hillside.

Mr. Sheldon spent several days investigating his new home. As hopeless as it appeared, he decided he would make the best of it. A good team of oxen and the rocks could be moved a little at a time to form fences and a barrier for the river. It sounded good. With

*Rocks, trees and the look of the land of the Pennsylvania Hermit.*

hard work, he could make a decent life here. Between farming and blacksmithing, it could work. Enough trees existed further in the distance that could be cut to make a nice home and a barn. After a few months, he returned to New Cambridge. He was anxious to share his plans with his wife.

Sadly, it was not to be. His wife's family was horrified to learn of the isolation of his new land. Her family convinced her to refuse to go with him. Her refusal broke his heart. Quietly, during the night, he loaded up his ox cart and left. Over the years, he learned to make the best of his cave home. Grass and trees began to grow in the land he worked. With the aid of the oxen, he moved enough rocks and dirt to create a barrier to keep the river from overflowing. He was busy, and very much alone except for the birds and the wildlife. Many animals became very tame and would visit him. The community nearby grew and children were welcome to visit his cave home. He would tell them stories about the forest creatures that he had learned from the Indians.

Occasionally, in his later years, he would go back to New Cambridge to visit relatives. He didn't stay long. New Cambridge had changed too much and he missed his solitude. The Pennsylvania Hermit found peace in his isolation. He died an old man and was buried in the cave home that he had learned to love.

# THE OLD EPISCOPAL CHURCH IN NEW CAMBRIDGE

O N FEDERAL HILL IN BRISTOL are the last remnants of the people of the New Cambridge Episcopal Church. It is the old cemetery that borders the Catholic Cemetery next to the beautiful St. Joseph's Church. In front of the cemetery is an old schoolhouse converted to apartments that once was the location of the New Cambridge Episcopal Church.

The first in the rows of graves is that of Mrs. Athildred (Mathews) Carrington, age 58, wife to Lemuel. Mrs. Carrington died December 10, 1811. The next is A. B. Carrington, Salmon Mathews, unknown, Mrs. Hannah Hill, Mrs. Ruth Mathews, Rhoda Royce, Maurice Mathews, Mrs. Nehemiah Royce, Mr. Stephen Brooks, Jarard Alling, John Hickox and Abel Roys. It is possible there are unmarked graves of which there are no records.

The inscriptions of the gravestones were copied by Charles N. Shepard, April 20, 1891. Fortunately Mr. Shepard transcribed the inscriptions before the carvings on the stones were lost to erosion. Mr. Shepard's inscriptions are on the following pages:

*The Old Episcopal Cemetery on Federal Hill.*

In Memory of Mr.
Jarand Alling Hoo
Departed This Life
September The 12 1794
In the 24 year of His
Age
You young companions all
Of the dere youth
That by his deth are cold
Read this truth
That suddin you may die
A Way your soul may fly
Into eternity
Which hath no end.

Here lies ye Body of
Mrs. Phebe Wife of
Mr. Thomas Beach she
Died April ye 30th 1758
In ye 91st year of
Her Age.

Here Lieth Interr'd
The Body of Mr
Stephen Brooks
Who Departed this
Life May ye 16th AD
1773 in the 71st year
Of this Age.
Behold & see as you Pass by
As you are now so once was I.
As I are now so you must be
Prepare for death & follow me.

A. B. Carrington
Departed this life
June 2, 1824
A.E. 29
[Footstone marked A. B. C.]

In
Memory of
Mrs. Athidred
Wife of
Mr. Lemuel Carrington,
Who died
Dec. 10th 1811
In the 58th year
Of her age.
A pleasing form, a generous gentle heart,
A good companion, honest without art,
Just in her dealings, faithful to her friend,
Belov'd in life, lamented in the end.

Hear Lies the
Body of Mr. Joseph
Gaylord Who
Departed This Life
Octr ye 20th AD 1791
In the 70th year of
His Age.

In Memory of
Mr. Cornelius
Graves Junr who
Departed this
Life October the
7th 1781 in the 25th
Year of his
Age.
[He is considered to be the father of
Stephen Graves of the Tory Den, but
Cornelius is most likely too young to have
been Stephen's father.]

Here lies
Ye Body of
Hannah wife of
Cornelius Graves
She died Novemr
Ye 17, 1759 in
Ye 34 year of
Her Age.

In Memory of
Mr. John Hickox
He died Febry 14th
1765 in ye 88th
Year of his Age.
[Footstone marked J. H.]

In memory of Mrs
Hannah Hill ye Wife
Of Mr. Dan Hill
She Died Febry ye
13th 1766 in ye
29th year of
Her Age.
[Footstone marked Hannah Hill]

In Memory of Capt
Caleb Mathews
Who Departed this
Life April ye 7th 1786
In the 83rd year of
His Age.
[Footstone marked Caleb Mathews]

In Memory of
Mrs. Ruth Consort
Of Capt Caleb
Mathews. Who
Departed this life
November 3rd
1785 in the 73d
Year of her Age.
[Footstone marked Ruth Mathews]

In Memory of
Mamre Daughtr of
Capt. Caleb & Mrs.
Ruth Mathews She
Died April ye 25th
1759 in the 14th year
Of her Age.
[Footstone marked M. M.]

In Memory of
Mr. Nathaniel Mathews
Who died Feb 15, 1806
Aged 78 years
Blessed are the dead who die in the Lord.
[Footstone marked N. M.]

In
Memory of
Mr. Salmon Mathews
Son of Mr. Nathaniel &
Mrs. Martha Mathews,
Who died
Dec 27th 1803
Aged 35 years
Death is a debt to nature due,
Which I have paid and so must you.

In Memory of Mr.
Abel Roys he Died
Septr ye 6th 1769 in ye 69th
Year of his Age.
Behold and se as you pass
By as you are now so once
Was I.
[Footstone marked A. R.]

Here Lies the body of
Mr. Nehemiah Roy
Ce Who Departed This
Life Feb
AD 1791 In the
69th Year of His Age.
Behold and see as you pass by
As you are now, as once was I
As I am now so you must be
Prepare for death and follow me.
[Footstone marked Nehemiah Royce]

Here Lies Buried the Body
Of Mrs. Rhoda Royce
The Wife of Mr. Nehemiah Ro
Royce, Who Died August
29th AD 1786 in the 61st
Year of her Age.
[Footstone marked Rhoda Royce]

In
Memory of
[this stone has been broken so portions of
the text are missing. Possibly it belonged
to Mr. Lent Rice who died 1809 age 42]
AE 42
Ten tender plants
To mourn my dear
O may we meet
When Christ does appear

Ten of these graves belong to founders of Bristol and the early Episcopal Church. The tradition of footstones dates back to England. The custom was to mark the grave at the head and the foot to prevent the living from walking on the actual grave. It was believed that walking on the grave disturbed the deceased and could arouse their anger.

*The Old Episcopal Cemetery.*

# IS TORIES DEN HAUNTED?

THE TIMES WERE CHANGING. INDIANS and settlers coexisted but it was still a tenuous relationship. Neither understood the other but as settlers realized that more land could be made available, more migrations took place. With the availability of good land, Indian land ownership was virtually ignored. The Tunxis Indians sensed that although they had attempted to assimilate, the chance to maintain their ways would be elsewhere. Some of the Tunxis had become Christians and went to school. But by the time of the Revolutionary War, the majority of Tunxis decided to join other tribes. Some went to Oneida, New York; Stockbridge, Massachusetts; and others joined tribes in Green Bay, Wisconsin. The last Farmington Tunxis Indian died in the 1820s. Place names are still named for the early Indian residents but their voices are just spirit whispers in the wind.

The world powers of the seventeenth and eighteenth century were challenging each other for mastery of the North American continent. The struggle for domination of Europe was ongoing too. It would lead the American colonies, whether citizens considered themselves British or American, into the fray. The French and Indian War was eventually a success for Great Britain. The confidence of the colonists was high. The American colonies were safe.

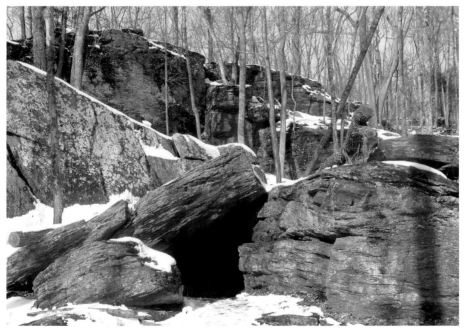

*Tories Den photographed in winter when very little vegetation remains. The trees have lost all their leaves. A portion of one of the Mile of Ledges is behind Tories Den.* Photo by Brian Armbruster.

Soldiers and officers of Great Britain treated the colonial soldiers with disdain, considering them contemptible. Hardworking American settlers resented it. Although the colonists often squabbled, they found that after the success of the French and Indian War, they had a common destiny. The colonies were settled by people of a rebellious spirit, and for whatever reason they felt that the Old World had rejected them. The trials of the journey to New England's wilderness created independence. Struggles to build homes, farms and a viable life instilled tenacity.

England looked to the colonies as moneymakers. Although colonists provided support during the wars, it wasn't enough. England needed money to restock her treasury after several costly wars and decided the colonies should help defray the costs of their protection. Each attempt by the King to tax the colonies, or generate revenue for England, was met with rebellion. Tensions heightened as talk about breaking away from English rule became more prevalent. Some colonists were ambivalent, wanting to work their farms and stay away from the dispute. Others were ardent revolutionaries forming the local band of the Sons of Liberty. Tories, or those loyal to England, found a measure of peace on Chippeny Hill, where kindred spirits and family ties merged.

The selection of Reverend Samuel Newell as minister of the dominant Congregational Church caused a number of families to declare themselves members of the Church of England. Rev. Newell was a strict Calvinist and many families just could not accept the rigidity of the Calvinist tenants. The dissenters formed the First Episcopal Society of New Cambridge and built their church in 1754 on Federal Hill. The Northbury (Plymouth) people formed St. Peter's Parish of the Episcopal Church in 1740. Church attendance was mandatory, therefore the greater the distance to church, the more difficult the journey. The choice to build a church on the top of Plymouth hill instead of in Plymouth Hollow caused a large portion of the families of Northbury to withdraw from the Congregational Church and join the Episcopal Church or Church of England.

The soil for farming on Chippeny Hill was rocky but once cleared made for excellent farms with water sources available for small industries. Possibly it was the challenges of life on the Hill that made those that settled there so obstinate. Some of the farms were settled as early as the 1720s. The farms on Chippeny Hill were predominately owned by members of the Church of England. Some preferred the Church of England because they were loyal to England, while others, even those born in the colonies, considered England home. Some liked the ways of the Church of England better than the strict Congregationalists. Later after the Revolutionary War, in a desire to stay together as their own community, they built their own church and named it St. Matthews Episcopal Church. It was dedicated in 1795. For a few years, during Revolutionary War times, the Episcopal Churches were closed. It was safer that way. The Sons of Liberty were very active with no qualms about harassing church members. The Sons of Liberty considered church membership of the Episcopal Church an implied sympathy for England.

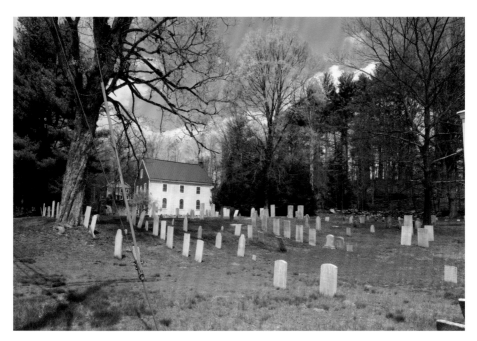

*St. Matthew's Church and cemetery.*

*The Ledges above Tories Den.* Picture by Brian Armbruster.

In times of distress, when the Sons of Liberty were about, the farmers who maintained their loyalty to England hid in the rock cavern within the Mile of Ledges called "Tories Den." Tories Den is a shelter of a large rock tipped and supported against another boulder. It is backed by an enormous ledge and well hidden. It looks like a pile of rocks that slipped from the ledge. Beneath the large slanted rock, a cavern has been created. In the days of the Revolutionary War, three men could stand upright and a total of fourteen could hide beneath the shelter of rocks. At one end, the opening is larger than the other, which helps to keep it hidden. The Tories at the southern end could walk out if stooped and those at the northern end could crawl. A small opening might have been a chimney, but smoke could have alerted the Sons of Liberty of its location. Many local Tories spent long cold nights hidden in Tories Den.

The actual location of Tories Den was not discovered until 1838, well after the Revolutionary War. A grandson of Stephen Graves and Bela Welton, young boys of fourteen, after spending the day hunting, accidentally found it. Local rumor suggests Tories Den might have a partly underground entrance, but one has never been found. Possibly due to the change of centuries, other rocks have become dislodged. Maybe the underground entrance relates to another den that is as yet undiscovered? With so many large rocks along the Mile of Ledges, it is certainly possible that other hiding places exist.

Stephen Graves was a frequent resident hiding in Tories Den. He seemed to be a favorite target of the Sons of Liberty. His home was a log cabin in the Harwinton forests. His young wife, Ruth, would provide food for the men hiding in the den. She would place the food on a large flat rock about a mile away. The Sons of Liberty could be watching so it was not safe to go closer. It is possible Stephen and Ruth's first child was baptized in Tories Den as Rev. Nichols often found himself hiding in Tories Den. Others that often found themselves in need of the shelter were members of the Tuttle, Carrington, Jones, Matthews and Jerome families.

Lemuel Carrington and his sister, Lois, kept a tavern on Chippeny Hill. Lois kept a kettle of water boiling on the stove, just in case the Sons of Liberty came calling. She planned a "warm" welcome for them. Captain Nathaniel Jones, after the war, testified how the Sons of Liberty raided cellars, destroying pantries to starve the women and children to force their men into line. Daniel, son of Simon Tuttle, openly joined the British forces. Daniel's land was confiscated by the State of Connecticut and sold at public auction for the benefit of the state.

Times were rebellious and hard. Many families, similar to the Civil War, had sons on both sides. Disunity tore families apart. Moses Dunbar was the only Tory executed in Connecticut for treason during the Revolutionary War, yet his brother Aaron served on the American side with honor. The father of Moses Dunbar offered the rope to hang Moses. The fragile times of rebellion and war left their mark on Chippeny Hill families.

Local legend states that the Tories hid their gold beneath or around Tories Den. Many treasure hunters have come seeking wealth, but would it be logical for Tories to hide their gold, when it could be used to support their own cause? Visitors to Tories Den have reported hearing voices, voices that did not come from earthly places. Sometimes there

is heavy breathing when no one else is about. Conceivably these are the ghostly sounds from the past of those in fear for their lives. Heavy footsteps of Tory hunters are heard. Spectral soldiers have been seen. Orbs float about the Tories Den. As a place of so much dissention and fear, residual sounds and lives remain. Perhaps the heavy breathing is Captain Wilson and the Sons of Liberty still searching for Tories?

# THE SMALLPOX VACCINE

Smallpox permeates written history. It was found in Egyptian mummies as long ago as 3,000 years ago. Ninety to ninety-five percent of Native Americans died when smallpox arrived on the American continent. The high percentage of deaths for settlers and Native Americans meant fewer hunters and farmers. Cultural traditions were lost and time for the hunt and harvest seriously declined due to lack of people able to hunt and harvest. Smallpox was responsible for vulnerability in societies from lingering weakness, blindness, deafness, disabilities and suicide. Epidemics of smallpox and other diseases such as yellow fever, dysentery, diphtheria, measles, scarlet fever and more were responsible for tragedies in society.

The Revolutionary War was solid ground for epidemics to spread. A few of the Northbury soldiers died in 1777 of smallpox. Hezekiah Tuttle, Enos Potter and Etai Curtis are just a few. Medicine had begun to make strides because of a few dedicated researchers and ambitious doctors. One was Dr. Eli Todd of Farmington. He was not directly related to Reverend Samuel Todd of the Northbury First Congregational Church.

Dr. Todd was the son of a New Haven merchant and a graduate of Yale. Todd was a brilliant pioneer in the field of treatment of the mentally ill and alcoholism. He was one of the early doctors to test smallpox vaccines. Dr. Todd's sister committed suicide and her death was the beginning of his commitment to kinder, gentler treatment of the mentally ill. In 1823 the Connecticut Retreat for the Insane was built with Dr. Todd as its first director. The specialty was what we today call "talk therapy." It was very different from the treatment of the times of locking up the insane in prison-like facilities. Dr. Todd also believed an abstinence from social pressure declined the usage of alcohol.

Hospital Rock in Farmington, in the woods of Rattlesnake Mountain, contains the remains of a smallpox inoculation hospital. The hospital, or "pest house" as inoculation facilities were often called, was run by Dr. Eli Todd and Dr. Theodore Wadsworth, who had treated smallpox while serving in the Continental Army. The two doctors were well established medical men when they founded the hospital in 1792.

Early inoculations consisted of infecting patients with a small amount of the smallpox virus until they showed a minor form of smallpox. By having a minor form, it created an immunity for the patient. Patients would spend several weeks at the hospital to contract the virus and recover. Hospital Rock provided a pleasant campus for inoculation and convalescence. This was the accepted process at the time. Abigail Adams, wife of former President John Adams, used a pest house in Massachusetts for the inoculation of herself and their children. One child did not contract the virus on the first inoculation, but on the second inoculation, he became seriously ill with smallpox but recovered.

In Northbury (Plymouth), Dr. Sylvanus Fancher was instrumental in the inoculation for smallpox. Dr. Fancher was the son of David and Sarah Fancher. He served in the Revolutionary War first under Captain Jonathan Bell in Lt. Colonel John Mead's Ninth Regiment of Militia, and later in General Wooster's Ninth Regiment of Militia. His brother James served under General Wooster's Regiment and at the siege of Boston.

Dr. Sylvanus Fancher spent nearly 40 years of his life researching a vaccine for smallpox. He received a diploma from the "Royal Jennerian Society of London." About 1796 in England, Dr. Edward Jenner noticed that milkmaids did not show symptoms of smallpox after variolation, an alternate form of inoculation for smallpox. He began experimenting with it. In 1801 Jenner published a treatise "On the Origin of the Vaccine Inoculation" in which he summarized his research in hopes it would eradicate the smallpox virus.

The Royal Jennerian Society was formed under the patronage of the Prince and Princess of Wales in 1803. The goal was to promote vaccination for the prevention of smallpox and encourage cities and towns to adopt vaccination measures for their communities. It was named in honor of the research of Dr. Jenner. Dr. Fancher was honored to be recognized by the Royal Jennerian Society.

# CAPTAIN WILSON AND THE SONS OF LIBERTY

THE SONS OF LIBERTY WERE the Revolutionary War's patriot band in search of Tories or anyone showing sympathy with the King of England. They themselves were law-abiding citizens—except when it pertained to Tories, those that included minsters and churchmen of the Church of England. Anyone with sympathy for England was not exempt from notice by the Sons of Liberty.

The southeast corner of Harwinton where Stephen Graves lived was on the edge of

Chippeny Hill. Stephen Graves' home was a common meeting place of Tory leaders and the favorite visiting place of Captain Wilson's Sons of Liberty. Captain Wilson was a Harwinton resident. He was an early settler to the wilderness, a determined man of about 64 years old at the time the Revolutionary War began. He served as a Deacon, captain, selectman and a deputy to the General Assembly. He was well versed in the issues of the day, and a well-respected man with an obstinate spirit. Captain Wilson is referred to as "dreadful full o' zeal" for the task of leading his very active band of Harwinton Sons of Liberty.

Wilson's home was nearly in Torrington, but in spite of the weather, rugged terrain, mud, irregular paths, rocky trails and very few rough roads, he was not deterred from his mission. The patrolling of the Sons of Liberty was not all bad—it maintained a margin of safety for the public welfare, if you were a patriot. For Loyalists, Captain Wilson's men were a force to be reckoned with, striking fear in the hearts of the men of England and their families. The men of Tory families, when working the fields, would take turns at each other's properties. They were careful never to be alone but to always have someone on hand to watch the hillsides for the approach of the Sons. Women too would be on guard. If the Sons were seen approaching, the tin horn of Mrs. Ebenezer Johnson would be sounded, or a conch shell in the case of Ruth Graves. At the warning sounds, the men would scatter. Some hid in attics, spaces behind fireplaces, cellars, caves in the woods or Tories Den.

Mrs. Stephen Graves would be the one to provide food to the men hiding in Tories Den. A large flat rock not too far from the Den was the place she would leave food, sometimes for weeks, before it was safe for the men to reappear. There certainly was reason to fear the Sons. Joel Tuttle was hung by the neck until nearly dead on Federal Hill Green. He was saved by a patriot named Captain Thomas Hungerford. Captain Hungerford saved Joel but feared to stay with him lest he might also be hung for rescuing a Tory. Joel Tuttle lay unconscious until later that night when he awoke and disappeared in the night to Tories Den. Joel's brother, Ebenezer, mindful of the near tragedy of his brother, yet a patriot himself, had a son born in January 1775 that he named "Constant Loyal Tuttle" in hopes of proving his loyalty in spite of the defection of his brothers.

It was not uncommon for the Sons of Liberty to visit root cellars and raid pantries to destroy the food of Tories. The intent was to starve the women and children into submission and bring the men into line. Chauncey Jerome, who married the widow of Moses Dunbar, was to his dying day, known as "Jerome the Tory." Even in his old age, he remained determined and strong yet would startle at the sound of the steps of a stranger.

The Sons of Liberty, with prisoners in tow, stopped at the home of a man whose name is not recorded. The man was one of the prisoners. Only one man was armed in the service of guarding the prisoners. The group had stopped at his home for water as they continued on their journey. The prisoners had been cautious but quiet, so the armed guardsman left his rifle leaning against the house. The wife of the prisoner and owner of the house was quick. She grabbed the gun and released her husband. He took the gun and watched over

*The grave of Constant Loyal Tuttle.*

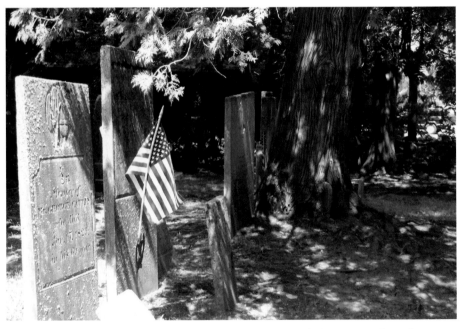

*Patriot's Grave of the infamous Captain Wilson, leader of the Sons of Liberty, at South Road Cemetery in Harwinton.*

the chagrined band of the Sons of Liberty as the wife released the prisoners. There is no record of the response of the embarrassed Sons of Liberty.

Reverend James Nichols, an ardent Loyalist who preached love of England and the King to his parishioners was several times a victim of the Sons of Liberty. Americans devised a unique favorite means of encouraging cooperation; it was called "tar and feathers." Reverend Nichols was once tarred and feathered and dragged through a brook, yet he never relented. Sometimes the tarred and feathered victim was given a ride on the rail. This meant that after a successful bath of tar and a liberal coating of feathers, the victim was seated on a very uncomfortable rail and paraded through town.

Whippings were also liberally applied. Stephen Graves always remembered the cherry tree he was tied to and whipped. He was not disappointed when the tree was cut down, but never forgot the scene at that stump. The Sons of Liberty of the Harwinton area were determined and led by a man who meant to make Connecticut free and remove the stain of traitors in their midst.

Captain Wilson is buried near the entrance to the South Road Cemetery in Harwinton—ready for any errant ghostly Tories that might dare to pass by.

# RUTH GRAVES AND THE CONCH SHELL

R UTH GRAVES, WIFE OF STEPHEN, was a timid young woman. She was often afraid of the noises of the deep forest where she and Stephen lived, yet when needed showed remarkable courage. Ruth was from the Jerome family, and she and two of her brothers were avid Tories. Her family was divided in terms of the Revolutionary War. Her father, Zerubbabel, and a brother marched to the aid of Boston. Another brother fought the British in New York and one who was living in Wyoming died fighting with General Washington in New Jersey. The Graves home was set in the wilderness of Chippeny Hill just over the Harwinton line. Pine trees, deciduous trees, berry bushes, wild flowers of all colors and varieties, rocks and a mass of woodland creatures lived in the area by the home of Mr. and Mrs. Graves. It was pristine and beautiful but also on the path of Captain Wilson's Sons of Liberty.

The wives of the Chippeny Hill Tories were a brave bunch, each watching for signs of Captain Wilson. Captain Wilson and the Sons of Liberty were famous for tormenting Tories. Upon sighting the approach of the Sons of Liberty, a chain reaction took place. Each woman had a whistle, horn or in the case of Ruth Graves, a very noisy conch shell. There are numerous

instances of Tories being hunted, whipped, tarred and feathered and in general, harassed. Homes were looted and storage cellars emptied by the Sons. The Tory men would work first one farm, then move on to the next one which allowed each to complete their chores and guard their fellow Tories from the approach of the Sons of Liberty. The threat was very real.

One day, Captain Wilson and the Sons showed up at the Graves house. Ruth had just hidden her precious conch shell beneath the straw and blankets of their bed. Captain Wilson hated Ruth's conch shell and from the front yard of the Graves home, he barked his demand for it. He wanted it and wanted it badly. Ruth calmly went back into the house, pretending to get the shell as Captain Wilson followed. Instead she took the chamber pot from under the bed and hid it under her apron. Quietly they walked outside, Captain Wilson sneering at his success—or so he thought.

After they were well outside of the house, Ruth removed the chamber pot from her apron. The smiling Captain quickly changed expression. Ruth turned swiftly and threw the contents of the chamber pot in the Captain's face. Imagine the expression: Captain Wilson with the contents of the chamber pot dripping from his long locks of hair in front of his men. Captain Wilson was outmaneuvered by little Mrs. Graves. She won this round—for now, anyway. She knew he would be back.

After a week or so Captain Wilson and his "friends" returned to the home of the Stephen and Ruth. Stephen was hiding in Tories Den as he knew the Captain was looking for him.

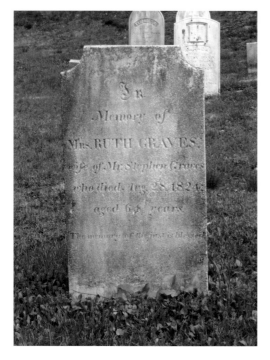

*The gravestone of Mrs. Ruth Graves, wife of Stephen.*

Captain Wilson arrived with a large group of the Sons of Liberty. He demanded the conch shell. He was angry and adamant—no tricks this time. Captain Wilson drew his pistol and held it to the head of a young girl in the care of Ruth. He stated he would shoot the child if the infamous conch shell was not turned over to him immediately. Ruth grudgingly relented and surrendered her beloved conch shell.

Many years later, upon hearing of the death of Captain Wilson, Ruth stated she was "glad of it." Stephen reminded her that it was her Christian duty to forgive. Yet Ruth, undaunted, replied it was not possible as he had not returned her conch shell.

# STEPHEN GRAVES'S COW

**W**HEN DRAFTED FOR THE CONTINENTAL Army, young Stephen Graves hired a substitute. When called up a second time, he refused to continue paying the substitute and would not hire a second. Although the error listing Stephen as available for service was eventually corrected, his refusal brought him to the attention of Captain Wilson's Sons of Liberty. Stephen was insistent he would not starve his family to pay for another substitute, nor would he serve.

Stephen Graves was believed to be the son of Cornelius Graves and Hannah Brooks Clark Graves. Stephen was born in February 1752 as the first of five children. Hannah died in November 1759, and after a short time, Cornelius married Phebe Prindle Graves. Stephen was quite young at the time of his father's second marriage. Stephen married when he was just short of his eighteenth birthday. He brought his young bride, Ruth Jerome Graves, to Chippeny Hill. He built a house on land given to him by his father. The land was in the Harwinton section. Their home became the rendezvous for Tories. Stephen and Ruth's families were well known for their support of England and the King.

Stephen became a favorite target of the Sons of Liberty but every attempt to break his loyalty to England was unsuccessful. He was a peaceful man but was not fearful. Stephen was captured by the Sons of Liberty as he returned home from a visit to his grandfather in Saybrook. His captors accused him of desertion from the military. As they headed back to Harwinton, Stephen walked and they rode. The Sons of Liberty required him to pay for their meals and travel expenses, but they eventually relaxed their vigil. Stephen was so calm and quiet they felt he was cooperative. Stephen had gotten far ahead of the escort on several occasions but without concern of his captors. When they were about three or four miles from his home, he turned and bowed, wished his captors a "good evening" and disappeared into the woods. When the Sons arrived at the Graves home, Mrs. Graves

was adamant Stephen had not returned. Stephen spent quite a few nights in Tories Den waiting for the Sons of Liberty to move on to other targets before he ventured home again.

Stephen Graves suffered greatly for his views but that did not change his mind. He remained loyal to England. Stephen had been captured by a mob and carried to the fork in the roads. He was tied to a cherry tree and severely whipped. Many years later, each time he saw that stump of the tree, he remembered being whipped at that site. Another time he escaped by climbing high into a large pine tree. He remained there until the Sons of Liberty had passed.

Even Mrs. Graves did her best to prevent the Sons of Liberty in their efforts. Ruth, who was usually afraid of the creatures of the night, interrupted the Sons of Liberty on their way to raids by blowing her conch shell as a warning. The Graves' family became such a bone of contention to the Sons of Liberty that even their livestock was suspected of Loyalist leanings and not safe from harassment. Captain Wilson, leader of the local band of the Sons of Liberty, arrived at the Graves home one afternoon. His band was in the act of driving off the Graves' cow. Quick-witted Ruth told them the cow was a loan and should not be the taken. The Sons assumed they had made a mistake and returned the cow. Captain Wilson's Sons of Liberty left empty-handed.

The Graves, in defiance, had the cow butchered rather than have it remain a pawn in the battle. It seems that not only families were divided over the war; even the cows became political pawns in Revolutionary War times.

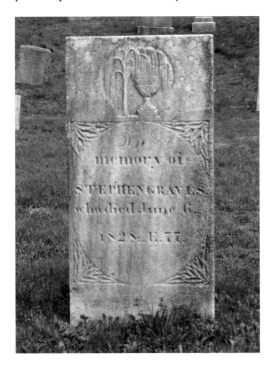

*The gravestone of Stephen Graves.*

# THE GHOSTLY TALE OF MOSES DUNBAR'S GRAVE

THE HILLS OF CHIPPENY INSTILLED a sense of independence as well as a sense of obstinacy. Perhaps it was due to the isolation, or maybe the finds of small treats, like wild strawberries, blueberries and gently flowing streams that created this notorious streak of independence. The times were difficult—some members of the community were ready for the break with England, others were ambivalent and yet some were prepared to fight to remain citizens of the Crown. Moses Dunbar was one such citizen.

Moses Dunbar was the second child of sixteen brothers and sisters. His father was John Dunbar III and his mother was Temperance Hall. John was an ardent Patriot even to the exclusion of his own son. Moses was born to this family on June 14, 1746, and executed on March 19, 1777, for treason. John offered the rope with which to hang Moses.

Moses married young, just short of his eighteenth birthday. Young Moses was about five feet eight inches with sandy hair and blue eyes. It must have been the blue eyes and sad expression that captured the heart of Miss Phoebe Jerome, sister to Ruth Graves. Moses and Phoebe were married May 30, 1764, and the parents of seven children at the time of his death. Two children preceded him in death. Phoebe Dunbar died on May 26, 1776; a child that was born a few weeks earlier died shortly after. Possibly Phoebe died of childbed fever as many women of the times did, or stress from the tension of the times.

Moses grew up in the Congregational Church. John Dunbar, Moses' father, was a Congregational minister. Shortly after Moses and Phoebe married, both joined the Church of England. This caused a serious breach between Moses and his father, yet Moses remained dedicated to the Church of England. He agreed wholeheartedly with the Reverends Scovil and Nichols. He said he did not understand the lawlessness on behalf of disagreements between Great Britain and the Colonies. He was quite vocal in his opinion against the taking up arms against Great Britain. At one point, he was surrounded and attacked by a large mob. He barely escaped with his life. The shock of this episode and fear for their lives took a great toll on Phoebe. The stress certainly was a factor in her death.

Shortly after Phoebe's death, Moses married a second time. His new bride was Esther Adams. Esther was the daughter of Samuel Jr. and Naomi Hotchkiss Adams. Samuel had been a corporal in the 1st Company, 4th Regiment under Colonel Elihu Chauncey in the French and Indian war. A divorce petition was filed in 1788 for Samuel and Naomi, citing adultery. The record does not state if the divorce was granted or which was the guilty party.

The threats to Moses continued as he was considered a traitor. Because of his views, he was required to face a Sons of Liberty committee and imprisoned for a maximum of five months in New Haven jail for his support of King George III. Upon release, Moses, unable

to contain his beliefs, travelled to Long Island. His intent in going to Long Island was to make a safe place for his family but while there, he accepted a captain's commission in the Royal Army under Colonel Fanning, which was under the command of General Howe. He was directed to recruit men for the Royal Army. He was successful until he spoke to John Adams (Esther's brother) and Joseph Smith.

Moses was captured and taken before justices Strong and Whitman of Farmington and they sent the matter to the Superior Court in Hartford. He was tried under the Treason Act of 1776, convicted of illegal recruitment for England and sentenced to death. The date of the execution was set for March 19, 1777.

March 1, 1777, with the aid of a knife given to him by an avid Tory (Elisha Wadsworth of Hartford), Moses was able to unlock his irons, push beyond a guard and escape. Moses was quickly recaptured. Wadsworth was ordered to prison for one year and to pay a large fine and costs of prosecution. The gallows were built near where Trinity College now stands. The pending execution was big news. Moses Dunbar was to be executed as an example to other rebellious Tories. *The Hartford Courant* published several notices of the conviction. Several attempts were made to contact General Howe to secure the release of Moses Dunbar, but none were answered. Apparently General Howe was too busy with his mistress and ill-gotten money to consider the plight of a lowly soldier.

The day of the execution came. Pregnant and deeply troubled, Mrs. Dunbar was ordered to attend the execution of her husband. Mrs. Dunbar stated that at the moment of the death of her husband, a white stag jumped from the bushes and ran beneath the body. She immediately left Hartford and went to Middletown to live with other Tory families. The kind families took up a monetary collection for her but no sooner was this done than she was ordered out of town. It was declared that if she was discovered there, she would be immediately imprisoned.

The sermon delivered by Nathan Strong, pastor of the first church in Hartford, was published many times. The title was "Bloody and Deceitful Men Shall Not Live Out Half Their Days." Tempers were hot on both sides of the issue of war with England. Isaac Dunbar, a brother of Moses living in Northbury, stated, "I see a sky and a man there. It is Moses Dunbar hanging!" Cruel as it sounds, Isaac had been blind for many years. His sighting came at the same hour as the execution of Moses.

The death of Moses Dunbar caused great sadness in Chippeny Hill. They had the infant Moses and the orphaned Dunbar children in their care. Moses Jr. did not survive to adulthood but the records do not give a cause of death. It was the Impulsive Chauncey Jerome that came to the rescue of the widow Dunbar. He was the brother of Phoebe Jerome, Moses' first wife. Chauncey, tall and muscular, had been captured by a band of patriots. They tied him to a tree by his shirt. The ever resourceful Chauncey slipped out of the shirt and escaped to the home of Jonathan Pond, his brother-in-law. Mr. Pond blocked the door and with gun in hand refused to allow the gang of patriots to reclaim their victim.

The question for many Tories was whether to stay and wait out the war or flee. Chauncey married Esther and took her and the family to Nova Scotia for the duration of the war. Later, they returned to Chippeny. Chauncey, to the day he died, was known as Jerome the Tory. Mrs. Jerome, upon a trip to Hartford with her husband, pointed out the spot by a tree where Moses was buried in an unmarked grave.

Moses Dunbar was buried in an unmarked traitor's grave at the Ancient Burying Ground in Hartford. Local legend says that after things calmed down a bit in Hartford, family members came in secret to retrieve the body and bury it in the East Church cemetery. In the back of East Church cemetery lies two rows of small gravestones only marked with numbers. These are pauper's graves, indigent or poor people buried at the expense of the community. There are 23 gravestones, and only 22 have names recorded on cemetery records.

Grave number 23 has a larger stone, but no markings on it. It lies at the end of the rows, slightly between them. Is this the final resting place of Moses Dunbar? East Church cemetery would be among his friends and family, rather than a lonely unmarked grave in Hartford. If you visit the cemetery during moonlit nights in March, a ghostly apparition may make an appearance. It seems that the death of Moses Dunbar was the cause of supernatural happenings, such as a white stag and a ghostly apparition at his grave. Is it

*The row of paupers' graves at St. Matthew's Cemetery in East Church. At the far-right edge is gravestone number 23. Inset: Mysterious gravestone number 23.*

Moses looking for his place in the world? Or is he atoning for his act of treason? Could he be warning others of his fate, not knowing that the war has been over for many years? Or is he just having some fun with anyone that passes by?

The cemetery at St. Matthew's did not open until 1795, nearly 20 years after the death of Moses Dunbar. Considering the intensity of the times, it is also possible the grave belongs to any one of the numerous personalities of Chippeny Hill.

# THE DETERMINATION OF MATTHIAS LEAMING

**M**ATTHIAS LEAMING WAS BORN JULY 7, 1719, in Durham, Connecticut. He moved to West Britain as a young man. He was the owner of a great deal of property and a member of the Church of England. On August 4, 1751, he married Philathea (whose name means "love of God"). Philathea was the daughter of Reverend Ebenezer Gould and Amy Brewster. Mr. Leaming's brother, Reverend Jeremiah Leaming, preformed the service.

Matthias and his esteemed brother declared their loyalty to the Church of England and by such they were declared to be disloyal to the American patriots. He and his brother would not give up their faith and were thereby considered Tories. Reverend Jeremiah demonstrated his politics as the Episcopal minister that went with the British to the burning of Norwalk. The property of Matthias was confiscated by the State of Connecticut. Matthias was a target of the Sons of Liberty and much maligned by his neighbors for his dogged adherence to his faith. It is not documented if he truly was loyal to the King of England, or just refused to relinquish the church he loved. Many fled to Canada for safety but this was not the way of Mr. Leaming. He would not be driven off.

Matthias's property was given by the State to Captain Benjamin Tallmadge of Litchfield, an aide to General George Washington, as a reward for his service. General Washington is known to have travelled through West Britain (later known as Burlington) on several occasions. The George Washington Turnpike is named in honor of the route travelled by General Washington.

Matthias died in Farmington, Connecticut, on September 6, 1789. He is buried in Memento Mori cemetery on Main Street in Farmington. It was at the insistence of Matthias that he be buried with his feet facing east, contrary to custom. The reason being that when the day of judgement comes, he will rise and his persecutors will have to face him. His headstone does not list his birth or death but proclaims:

In memory of Mr. Matthias Leaming who hars got beyond the reach of persecution—The life of man is Vanity.

It seems that even in death, Matthias Leaming remains true to his convictions.

# ISAAC SHELTON, THE UNREPENTANT TORY

ON A MILD SUNNY AFTERNOON, April 25, 1777, 26 British ships anchored at the mouth of the Saugatuck River in Fairfield. By sunset, 2,000 well-armed troops disembarked to begin the march to Danbury under General Tyron. General Tyron was also the Royal Governor of New York. Their guides were local Tories, one of which later resided in Northbury (Plymouth), named Isaac Wells Shelton.

Isaac Wells Shelton was the son Samuel Shelton and Abigail Nichols Shelton. The Shelton family was wealthy and owned extensive properties in Stratford. Isaac was born March 11, 1756, the eighth of nine children. While visiting his cousin, Captain Jones at Chippeny, he fell in love with Martha. He married her. Martha was his second cousin and they married on November 12, 1780. Three of their children died young. The second child, Charity, survived and married into the Bartholomew family. Martha died in 1809 at age 46. The records disagree if Isaac married Nancy Starr in December 1812. Isaac died 1831.

Early in 1777, General Washington ordered that Danbury serve as a supply depot for the Continental Army. The decision was based on the town as a regional trading and manufacturing center. It could be easily reached by several major roads. Supplies were to be guarded by Colonel Jedediah Huntington and a militia company under Colonel Joseph P. Cook. The British were deeply entrenched in Long Island and New York City. Danbury, with its military stores, was within easy reach of British lines with a couple of qualified guides—the Colonial supplies could be destroyed. Connecticut Tories were enlisted as guides, one of which was Isaac Wells Shelton.

The British, under the command of Captain Duncan under General Tyron, landed 1,500 British regulars and American Loyalists at Westport (then called Compo Beach) by 5 P.M. in the afternoon. It began to rain as the march to Danbury began. The troops stopped to rest in Bethel. In the morning, the march began again. Word had spread but it took time to get sufficient men to Danbury to protect the city. Within 24 hours the British reached the city. Supply houses and private homes were burned. Tory homes were marked with

white crosses to identify them as loyal to the crown and thereby protected. Supplies were dragged into the streets and set on fire. A large store of rum was discovered and drinking and debauchery followed. It was the next day the drunken, slovenly British army moved on.

Many of Connecticut's citizens remained loyal to England but as times grew difficult, laws were enacted that would confiscate property and possibly compel prison time. Captain Abraham Hickox had been a deputy sheriff in Waterbury, but withdrew to British lines. His property and mill at Greystone were confiscated and sold for the good of the state. Silas Hoadley later bought the property and used the mill for clock making. The estate of Samuel and James Doolittle, Joel Hickox (son of Abraham) and Reuben and William Hickox, among others, went over to the British side. Moses Dunbar was executed as a traitor. Others were tried, imprisoned, their property confiscated or fined. It was war.

Isaac lived in Stratford at the time the Revolutionary War started. He joined with the patriots, but could not tolerate the demeaning treatment by another officer—he struck him and fled. It was then he spent time in hiding with the British and joined the British. Later, the town of Stratford, in 1779, resolved that Isaac Wells Shelton could not live within its boundaries because he was one of the leaders of the raid that burned Danbury. He was arrested and ordered to confine himself to Hartford County. Isaac moved to Chippeny Hill.

On the eve of the Revolutionary War, Connecticut had more slaves than any other New England state. The importation of slaves was prohibited as of 1774 and in 1784 gradual emancipation was made into law. Isaac Wells Shelton retained his slaves—whether they

*The gravestone of Isaac Wells Shelton.*

stayed willingly or because they had no place else to go is not known. Isaac was well known for showing off his high wheeled gig with spirited horses driven by his former slaves. Mr. Shelton was a short man, dressed in the knee breeches of the day with prominent grey "bullet" eyes. In his later years, Isaac was quite ill with "softening of the brain." Yet he did not trust his slaves with his care. He was fearful of being alone, so a caretaker had to be hired.

Rumors persisted that his money was not earned by honest means and the stain of the Danbury raid remained with him. He continued his membership of the Episcopal Church when it reopened after the war. Yet, in spite of the rumors, when Isaac Wells Shelton died, all came to honor him as his body was laid in its grave as a gentleman.

Isaac was laid to rest in the cemetery at St. Matthew's Church and his former slaves are buried in pauper's graves in the back of the same cemetery. He never apologized for his time with the British, nor asked forgiveness. He died as a Tory, unrepentant to the end.

# THE HERO AND THE VILLAIN

ORMATION OF EPISCOPAL CHURCHES WAS a sign of the times. Many Episcopal Churches were formed in the early days of the 1740s. In Northbury, St. Peter's Episcopal parish formed when eleven of the eighteen families of Rev. Samuel Todd's Northbury Congregational parishioners broke away. The problem wasn't a disagreement with Rev. Todd, but a disagreement over the location of the church. Some wanted it in the "hollow" or valley portion of Northbury. Others lived on the hill and wanted the new church closer to home for them.

The first minister of St. Peters was Rev. Theophilus Morris, sent by the English church for the propagation of the gospel in foreign parts. The term foreign parts included the American colonies. The early churches depended greatly on aid from the English to provide support and ministry. The first church structure was built in Plymouth Hollow, the later at Plymouth Green. Rev. Morris was followed by Rev. James Lyons, then a short time later by Rev. Richard Mansfield, who received his Holy Orders in England.

At about the same time, New Cambridge (which later became Bristol) residents tired of the long pilgrimage to the meeting house in Farmington, and thus formed their own Episcopal church on Federal Hill. The journey was rough, over rugged trails, through forests and over fording rivers, all while watching for Indians and wild beasts. The year was 1743 when the Ecclesiastical Society broke away from the Congregational church. The parish was named New Cambridge. Rev. Samuel Newell was the pastor of the Congregational Church and a serious Calvinist. His rigid teachings were bitterly opposed. It was this rigidity that caused the

*St. Peter's Episcopal Church before it was totally decimated by fire in 1915.*

breach in New Cambridge. Caleb Mathews, Stephen Brooks, John Hikox, Caleb Abernathy, Abner Mathews, Abel Royce, Denell Roe and Simon Tuttle publicly declared themselves of the Church of England and under the jurisdiction of the Bishop of London. Soon they were followed by Nehemiah Royce, Benjamin and Stephen Brooks Jr. and Joseph Gaylord.

England was still considered home for many colonists. They loved to hear what the King was doing, who was at court, who had been knighted and what new cathedrals were being sponsored by the King. The King and the nobles were the celebrities of the day. The English church was a gentler church. Christmas meant presents, big dinners, fancy desserts, decorations and happy celebrations. The early Puritans were a sober, stiff lot. To the Puritans, such celebrations were considered the devil's work.

Early colonists were a religious bunch. Taxes were collected for the support of the primary church. Those of the Episcopalian faith were taxed both for support of Puritan churches and to support their own church. In 1749, several families refused to pay for the Puritan church and were sent to Hartford jail until their debt was paid. Society was based on religion. The churches provided guidance as well as a meeting place for local government.

The land for the New Cambridge Episcopal Church was deeded to the Society by Stephen Brooks. It was located on four acres on Federal Hill Green. The church opened for services on June 10, 1754. Prior to that, churchmen met at private homes. When Rev. Mansfield retired, the society petitioned for Rev. James Scovil, a Yale graduate of the class

of 1757, to replace him. Rev. Scovil was responsible for the churches of New Cambridge, Waterbury, Northbury and Westbury (Watertown). Membership greatly increased under Rev. Scovil. In 1762, Farmington was added, and Mr. James Nichols was appointed to assist.

Rev. James Nichols was ordained in 1774 to the parishes of Northbury and New Cambridge. He was the son of James Nichols, born December 1748, and graduated from Yale in 1771. His mother was Anna Porter, daughter of Daniel and Deborah (Holcomb) Porter and the widow of Thomas Judd. Daniel Porter was a physician in Waterbury and the Nichols family were large land owners in Waterbury. Rev. Nichols was ordained in England, the last minister to take holy orders in England. He settled in Plymouth but later moved to Litchfield in 1775, then Vermont. He died at Stafford, New York, in June 1829.

Rev. Nichols came to Northbury and New Cambridge with excellent recommendations. He was noted for his love of England and was an avid loyalist. Chippens Hill was the gathering place for Tories from all over Connecticut. Soldiers were enlisted for King George and Tories Den was the favorite hiding place. Rev. Nichols was well known for imbuing loyalism in his flock. The 1770s were a dangerous time to be loyal to England. Rev. Nichols was shot at several times for instigating Loyalism. Once he was found in the cellar of Cyrus Gaylord's home in East Plymouth. He was forcibly removed, tarred and feathered and dragged through a brook. Rev. Nichols hid in Litchfield as a fugitive.

Rev. Nichols made periodic visits to New Cambridge. He administered baptism once in 1777, then not again until after 1780. The last baptism at New Cambridge was performed on January 30, 1780, for the daughter of Stephen Graves, but the location is not recorded. Legend has it that the baptism was performed in Tories Den while Stephen was in hiding. Rev. Nichols was well liked but the Episcopal Church was not liked by patriots. History has recorded that when George Washington passed through Litchfield, his soldiers showered St. Michael's Episcopal Church with stones. General Washington put a stop to it, saying he was a churchman and would not see anyone's church so dishonored.

When Moses Dunbar was tried by the Superior Court in Hartford for treasonable practices against the United States, Rev. Nichols, also imprisoned, was acquitted. Moses was executed. On May 22, 1777, seventeen Tory prisoners from New Cambridge were examined at the home of David Bull by a committee of the General Assembly and were found to be "much under the influence of one Nichols, a designing church clergyman." Episcopal Church services were discontinued due to the instability of the times. A few church members maintained their faith in private homes but carefully, so as not to arouse suspicion by the very active Sons of Liberty.

After the Revolutionary War, Rev. Nichols did much to rebuild the church community, but eventually Rev. Nichols left the Northbury and New Cambridge parishes, resigning in May 1784. Rev Nichols was involved in a serious legal matter of selling a farm to Jonathan Pond with an unclear title. After much legal maneuvering, Mr. Pond raised the money to purchase the farm a second time. Afterward Nichols moved to Vermont. He became the

*Revolutionary War reenactors.*

rector of St. James Church but on June 4, 1788, the Rev. James Nichols, by his intemperate habits, lost the respect of his people. He was dismissed. He died miserably at the home of one of his sons in Stafford, New York. His suspension from the ministry was initiated by Bishop Griswold, a former friend of Rev. Nichols.

It has been said that Rev. Nichols led the church in war and Rev. Alexander Viets Griswold led them in peace. Rev. Griswold was a real gentleman and a hard worker. He boarded at the home of Cyrus Gaylord. Griswold was peaceful and plain but of great physical strength. When he saw a group of men trying to move a large rock, he joined in, seized the stone and freed it from its resting place. With his home in St. Matthew's East Church, parish traveling to hold services in rough country with bad roads was difficult, yet he never reneged on his duty. He was always available for his flock. He was the nephew of Rev. Viets of Simsbury who ministered to the doomed Moses Dunbar. Rev. Alexander Viets Griswold was ordained by Bishop Seabury on October 21, 1795, when St. Matthew's Episcopal Church was consecrated. Rev. Griswold is credited with building that church. He loved St. Matthews and the people of Chippeny Hill. He said those years were the happiest of his life. Yet on one occasion he was the means to remove a man of his parish. The man left Connecticut as an absconded debtor and was removed from his church in Vermont for being a drunk. That man was the former Rev. James Nichols.

Griswold was a hero of his people, and Nichols became its villain.

# EARLY NEW CAMBRIDGE

**E**ARLY CHURCHES WERE AN INTEGRAL part of life for New Englanders. Congregational churches formed a basis for life in communities. They provided strength for a hard life of creating a new settlement in the wilderness. Churches brought people together, formed a common bond, and gave protection from the shared elements and shared dangers. The church was also a form of local government where community or personal grievances could be aired and hopefully resolved.

The first settlers of New England had come for religious freedom. They were Separatists, also known as Congregationalists, or those that had left the established church. In England they were hunted, imprisoned and exiled, and some were executed for their beliefs. Eventually the Puritan clergy became so extreme and domineering that many seceded to the Church of England.

Missionaries were sent by the Society for the Propagation of the Gospel for the Church of England and under the care of the Bishop of London. By 1727 the Episcopalians were recognized as dissenters. In 1729, the Episcopalians, Quakers and Baptists were granted a degree of toleration. This toleration gradually evaporated as dissatisfaction with England and the King grew. Alliance with the Church of England became synonymous with disloyalty to the American colonies.

At New Cambridge, the Episcopal Society needed a church building. Stephen Brooks deeded to the society four acres of land which adjoined the land of the Congregational Church. Land was provided for a burying ground. The burying ground was used as a pasture and it is possible that many of the original graves have been lost as the graveyard has contracted to a very small area. The church was located in front of the graveyard. It opened for services on June 10, 1754. With the two churches and a school house, the site became an active community center called, "Federal Hill Green."

The Episcopalians were forced to make some difficult decisions. Their prayer book included a prayer for the King to be victorious over his enemies. Another was the wording, "our excellent King George." Should they be defiant of the patriots, or disobedient to the canons of their church? The decision was to suspend services until after the Revolutionary War. The New Cambridge Episcopal Church was closed.

After 1784, the New Cambridge church reorganized with 29 members. The old church structure was unfit for use. It was decided to build St. Matthew's church at the base of Chippens Hill, rather than repair the old church.

*St. Matthew's Church and cemetery, also known as the Tory Church and cemetery.*

# THE PAUPERS OF EAST CHURCH

AFTER THE REVOLUTIONARY WAR, THE New Cambridge Episcopal Church was in disrepair. It had been deserted during the war. The surviving members were too few to rebuild and voted to join with Chippeny Hill Episcopalians to form a new society. The result was the formation of St. Matthew's Episcopal Church. Therefore, in 1790, the Church was initiated in East Plymouth, also known as East Church. This portion of Plymouth borders Bristol, Harwinton and Burlington. Episcopal Churches were finally able to reopen after the Revolutionary War.

The signers of the Petition for the Establishment of a Church at East Plymouth on October 1, 1790, are listed below:

Caleb Matthews, Clerk of the Episcopal Society in New Cambridge (Bristol)
Stephen Graves
Curtis Hale
Calvin Woodin
Ozias Tyler
Moses Cowles
Ira Dodge

Isaac Miller
Samuel Hawley
Daniel Bowen
Oliver Loomis
Robert Jerome
Jabez Gilbert (bard)
Jonathan Tyler
Asa Smith
Noah Welton

Ezra Dodge
Thomas Curtis
Ebnezer Cowles
Eliphalet Barns
Abner Woodin
Jacob Mallory
Amos Wright

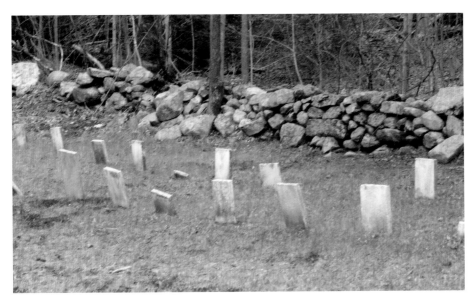

*Paupers' graves.*

Ozias Tyler's home was the place of the first meeting on April 4, 1791. Ensign Tyler and Captain Nathaniel Jones were chosen to be moderators. The top priority of that meeting was to determine a place to meet for worship for the coming year. The next meeting was December 1, 1791, where it was voted to build a church building. It was determined that the structure was to be 42 feet in length and 32 feet in width. A committee of Isaac W. Shelton, Samuel Hawley, Ozias Tyler and Stephen Graves was formed to build the church and determine the location. The committee also wanted the lower tier of windows to be arched and the upper ones to be square.

The building was completed with a south-facing entrance, which was changed at a later date. The building was built in 1792 but the inside was not completed. Another meeting was held and Isaac W. Shelton and Stephen Graves were appointed to put out the funds and find someone to finish the inside of the building. Another meeting was held to complete the interior. Finally, a meeting was held October 19, 1795, where the name of the church was voted to be "St. Matthew's." It was also voted that the church should adopt the constitution of the Protestant Episcopal Church of Connecticut. St. Matthew's Episcopal Church was consecrated by Bishop Seabury on October 21, 1795. The same day, Reverend Alexander V. Griswold was ordained priest. The adjoining cemetery was opened in 1793 when a gravedigger was appointed. The earliest records of burials have been lost. Junius Preston was appointed sexton in 1846, a post which he held for 41 years. The Preston records still exist. In the very back of the East Church cemetery are 23 graves of paupers or those that were unable to pay for their own burials. This information was filed in the

Plymouth Land Records on September 9, 1886. The first stone gives the volume and page numbers for the names and locations of 22 of these graves as follows:

East Church

Volume 32, Page 276 and 277 Plymouth Land Records

Location of Graves of Town Poor at East Plymouth

In the cemetery at East Plymouth there are in the northeast corner near the church twenty-three graves which are known as the town poor. Three or more were formerly Connecticut slaves. And as this cemetery has recently been cleared up, improved, and grave marks placed at these graves, without names. A list as near correct as I have been able to obtain and which was copied from a book left by Mr. Junius Preston who with his father before him has been Sexton for the past sixty-four years.

The north end row—grave marked number 1 is Amos Howe, next Maria Hungerford, James Scott, Eunice Sears, Phila Russel, David A. Blackman, Jacob Whitaker, Peter Primus, Mrs. Peter Primus-papers now in existence show that Primus, a slave was sold for thirty bushels of Rye. This completes the east row being nine graves and nine names.

Commencing at the north end of the west row is grave marked number 10 this is Belinda Case. Next is Edward Painter. Julia A. Shelton, John Case, Clara Suttiff, Oliver Suttiff, Henry Schunder, William Bell, Mary Rowden, Floyd Blakeslee, John Wright, Charles Hawley, Winthrop Fenton. This makes twenty-two names while there are twenty-three graves which makes on this west row. One unknown. Amos Howe

Maria Hungerford

James Scott

Eunice Sears

Phila Russel

David A. Blackman

Jacob Whitaker

Peter Primus-slave

Mrs. Peter Primus

Belinda Case

Edward Painter

Julia A. Shelton

John Case

Clara Suttiff

Oliver Suttiff

Henry Schunder

William Bell

Mary Rowden

Floyd Blakeslee

John Wright
Charles Hawley
Winthrop Fenton
One unknown

Mr. and Mrs. Peter Primus had been slaves. Peter was the son of Cambridge and Moriah, possibly born July 9, 1784. Peter had a brother named Ham that was born July 7, 1787. The recorded document above is filed on Town of Plymouth records and states that Peter was once sold for 30 bushels of rye. His death is not recorded. There is no information on his wife. David Blackman was also a former slave. Isaac W. Shelton was known to own several slaves, most likely including Peter and his wife, along with Mr. Blackman. The rest of the deaths of the poor range from 1864 to 1885. No information has been located on the owner of grave number 23.

# FOLLOWING THE NORTH STAR

SECRETLY THEY TRAVELED THROUGH THE wilderness in the dark of night, following the North Star to freedom. The few roads that existed were not safe for runaway slaves. The way was long, treacherous and along wilderness paths, through dense, nearly pristine forests to meet the next conductor who would, when safe, forward them on to the next station or set them back on the proper path to continue their journey. Sometimes alone, sometimes as families, sometimes in groups they traveled north to Canada for safety and freedom. Slaves were forbidden to learn to read and write, worship as they chose, travel as they pleased and forsaken the fruits of their labors. Many chose to escape and make the long journey to Canada. Frequently it took many months to walk from southern states to the Canadian border with the aid of "conductors" or those who courageously risked their own safety and livelihood to assist these souls on their journey along the Underground Railroad. Signs might be a lantern, a misplaced sign or even an overturned cup to designate a safe house.

In Plymouth, the Blakeslee family, William Bull and Daniel Dunbar were ardent abolitionists and conductors on the Underground Railroad. Joel Blakeslee was a known conductor, historically known for a cordial welcome and hearty meal at his home for those in need. The ones that lost their way on the path northward could expect Joel or one of the other conductor's watchful eyes to find them and to set them back on the right path as soon as it was safe to continue. Joel's son, Erastus Blakeslee, who attended college at Williston Seminary in Massachusetts and later from his pastorate in Boston, was known for his sermons on the ills of slavery.

The northeast gradually adopted laws moving toward emancipation. The 1784 Connecticut General Assembly passed gradual emancipation for all slaves born after March 1, 1784, who would become free at age 25, but even then the law did not apply to slaves 64 years and older. Slaves 64 and older continued in slavery as a means to require the master to support them when they were no longer able to work. Evidently Mr. and Mrs. Primus and Mr. Blackman chose to remain in East Church or were older than age 64 at the time the law was passed.

# LITTLE GIRL LOST

T HE AFTERNOON WAS SUNNY AND bright but it was getting late. Soon the shadows would fall as the sun sunk lower on the horizon. The birds became quieter as the sky darkened. The gentle breeze slowed even more, and the rustling of the leaves stopped. A silence permeated the late afternoon until it was broken by the voices of Rachael's parents calling for her.

The evening stillness cast a pall over the Chippeny Hill ledges. Caleb, Rachael's father, called several more times. He wasn't sure if he should be worried or angry. Rachael was always such

*Remnants of a stone wall on Chippeny Hill*

an obedient child. Even at eight years old, she was quite responsible. Rachael was careful to watch over her younger siblings. Her chores were always done on time. Sometimes he could hear her singing as she fed the chickens. Caleb smiled as he thought of Rachael and the new puppy he had given her. It was the runt of the litter and no one wanted it. Caleb really didn't either, but the poor little thing was so small when she lost her mother that he wondered if it would survive. If it didn't it would break little Rachael's heart, but he knew if it had a chance Rachael was the one to help her. Rachael saved the pup, with her gentle spirit with kind hands. Caleb smiled to think what a good mother she would be someday when she had a family of her own, not just caring for the runt of the litter or an army of farm animals that followed her everywhere, but her own children learning and following her gentle ways.

A clap of thunder awoke Caleb from his daydream. Rachael still has not returned. Caleb had been near the pond, helping his neighbors cut wood for the winter and finish off their house before cold weather set in. The men were working so diligently to cut the stand of old maples that he lost track of Rachael. The pleasant afternoon, the breeze, the comradery of friends and neighbors had taken his mind off his daughter. His attention was drawn back to reality as his eyes searched the area. No Rachael.

He called to his wife, Mary. Maybe Rachael was with the women making jams and jellies for the winter. Mary came asking what was wrong. Everyone had been so busy no one noticed the missing child. Everyone began to gather near the open area at the top of the dam where the men had been clearing trees. The men divided into groups to search for Rachael.

The groups separated, each taking a section to search for Rachael or clues as to where she may have gone. This was so unlike Rachael. She was such a good girl. Mary walked the top of the dam, alternating between wringing her hands and wiping them on her apron. It was nearly dark now, making the search more difficult.

The land near the dam was only open and flat in a small area. The rest was deep pine and maple forest with tree stumps. The thick growth woodland protected the nearby home of Samuel Smith from the bitter winds of Chippeny Hill. Samuel's home was where the women gathered. They were making quilts for the newlywed couple, jams and jellies and dinner for everyone. The day had been productive for both the husbands and their wives. A quilt was completed and a large amount of wood was ready for the Smiths and for the minister, as part of his agreement to minister was a supply of wood. The best part was the apple pies!

Apple trees thrived on the Hill. They were a delightful source of treats for everyone, providing apple butter, pies, preserves, vinegar and a supplement for the livestock. The smell of the pies and apple butter made everyone drool with hunger.

Another clap of thunder brought everyone to attention. Rachael's trail was not found, nor was Rachael. Now everyone was in a panic but it was dark and little could be done until morning. Samuel's wife, Lucy, did her best to comfort Mary and assure her Rachael was a smart girl who probably found a warm spot in the pines to wait for morning. Everything would be better in the morning—she hoped.

After a long and restless night, the colonists returned, hopeful that Rachael had come home. But it was not to be. Rachael was still missing long after the sun arose. The search began anew. Hours later, no trace had been found. Samuel walked the trail that really wasn't much of a trail, but a parting of bushes that ran next to the pond that was formed by the dam. The path was relatively unknown because it was hardly noticeable. Samuel remembered he had shown the path to Rachael only yesterday. He knew Rachael would love to sit on the old broken tree to watch the family of ducks. Their eggs had just hatched. The nest was located at a small inlet hollowed out by flowing water. It was easily visible from the tree and just far enough away not to frighten the ducks. Rachael loved to take off her shoes and stockings to dip her feet in the water. Samuel wondered if Rachael had fallen asleep or curled up inside the hollow of the broken tree stump for shelter from the storm. Samuel walked with determination to the old tree, not sure if he should be angry at the child or delighted if he found her.

Samuel was a big man. It only took him a few steps to reach the tree. He called to Rachael, his deep voice booming against the rocks of the nearby ledges. No answering call came. There was no sign of Rachael until he reached the hollow stump. He found one stocking. Samuel took a deep breath as he looked out over the pond formed by the dam he and his neighbors built. A small shoe floated past. He choked as he ran to Caleb and Mary.

*Rachael's perch to watch the ducks.*

A crowd formed as he related his story of the baby ducks, the broken tree perch and the hollowed out stump. Panting, he stopped talking and held up a single pink child's stocking.

Loud gasps came from the crowd. Heartbreak and panic ensued. Neighbors talked and many voices of fear could be heard, speculating what had happened to Rachael.

The murmurs grew louder and louder as Caleb's voice took over. He was adamant— Rachael must be found, no matter what! As a community, he said, they would never be the same if they did not find Rachael. The evil would engulf them until it consumed them all.

With a strong hard step Caleb walked to the dam. It was the dam he and his neighbors built to keep a supply of water and run the mill. The dam that would provide water in time of drought or times when the spring rains threatened flooding. Angrily he began to remove stones from the dam. Stones that in any other circumstances he could never lift. He tossed them aside, intent on destroying the dam that had taken his Rachael. He had to have her back. He had to rescue her. He had to find her.

Mary watched in horror as her husband moved rock after rock. His hands were bleeding yet he did not stop. It wasn't long before his friends and neighbors joined him. Piece by piece they worked through the day to demolish the dam they had so carefully built. The water flowed out until the pond became a puddle. By midnight with a full moon the valley where the dam had been showed a large gaping hole.

*Rachael's ducks.*

No trace of the child was ever found. Caleb collapsed at the base of the former rock and earthen dam and sobbed. His tears could have filled the pond but nothing could change the truth. Little Rachael was gone and so was the structure the community had so carefully built.

The dam was never rebuilt and the cut wood never used. Gatherings of neighbors at the site never happened again. The site was abandoned. The Smiths moved away. The site was cursed by those who had so hoped it would be beneficial. All that remains is the empty dam and the hollow voices still searching for a loved lost child.

# THE PASSAGE OF TIME

Change had come unnoticed, quietly, without warning.
More time than she realized had passed.
This place had always been peaceful, quiet,
just her and the bluebirds.
It was the quiet of butterflies, summer flowers, and the silent sounds of nature
that drew her and her wounded soul.
Tiny sprigs of blue-eyed grass, flowers of some kind—
Elaine wasn't sure what they were—
also decorated the field.
It didn't matter what they were,
the flowers were there,
and that was the important part.
Meadow flowers covered the field
crowning it with spectacular seasonal colors.
Elegant primeval looking trees lined the edges of the old fields
as this once had been thriving pasture land.
Stonewalls in disrepair separated the sections in the distance.
Broken granite posts with metal bars
once held gates in times long past.

Gentle fuzzy deep green moss by the east end of the pasture grew
where the morning sun poked through the ancient trees.
She always walked to the sunny place
on the little mossy knoll.

The winter storms left one of the old oaks broken there.
Was it symbolic of the future?
Only the forest creatures knew where she was
and they would not tell.
She felt temporarily safe from her demons.
Nature would wait for her and gently include her in this world
for as long as she wished its shelter.
Sometimes squirrels or even a raccoon would patiently sit at her feet
as she meditated and collected her thoughts.
The birds weren't afraid of her.
They often brought their families to visit.
She loved the sounds of the wind in the leaves
mixed with the voices of squirrels chattering.
The gentle sounds of tiny feet as the creatures chased each other.
The scurrying and scolding of the squirrels and chipmunks was calming.
Elaine patiently watched as they played.

Then suddenly—
or maybe she just hadn't noticed that impending change was hovering—
the world was moving on,
past the pastureland days and into a new time
motivated by profit.
It had hung over the old farm like Damocles' sword.
The land had been sold.
The old oak trees she loved would be gone.
Fifty acres of farm land was worth a fortune.
Nature had no place in profitability.
The meadow would be chopped up by huge construction machines.
The machines would bring the demise of Elaine's precious wildflowers.
It was the death knell of the peaceful meadow,
looming like a giant dark mushroom cloud.
Soon the meadow would be no more.

Like so many things, the meadow would be gone;
no longer of this world, its former existence
becoming as dead as winter.
Its reality becoming unreachable, untouchable—
existence denied.
Now the peaceful meadows of Chippeny Hill could only live in her soul,

And in her heart now,
it had a place,
but with the finality of the grave—
in reality, her meadow existed no more,
and how she wished she could touch them again.

*A squirrel resting on a gravestone as if time had stopped*

# BIBLIOGRAPHY

Alderman, Leonard, Burlington Town Historian. *Articles of Burlington Connecticut's Past.* 1991.

Anderson, Joseph, Prichard, Sarah J. *The Town and City of Waterbury, Connecticut, from the Aboriginal Period to the Year Eighteen Hundred and Ninety-Five Volume I.* New Haven, Connecticut: Price and Lee Company, 1896.

Anderson, Joseph, S. T. D. *The Churches of Mattatuck: A Record of A Bicentennial Celebration At Waterbury, Connecticut, November 4th and 5th, 1891.* New Haven, Connecticut: The Price, Lee & Adkins Company, 1892.

Atwater, Francis. *History of the Town of Plymouth Connecticut Centennial Celebration May 14 and 15, 1985.* Meriden, Connecticut: The Journal Publishing Company, 1895.

Barber, John Warner. *Litchfield County Connecticut.* New Haven, Connecticut: Durrie & Peck and J. W. Barber.

Bickford, Christopher P. *Farmington in Connecticut.* Canaan, New Hampshire: The Farmington Historical Society, 1982.

Boyton, Cynthia Wolfe. *Connecticut Witch Trials: The First Panic in the New World.* Charleston, South Carolina: The History Press, 2014.

Brandegee, Arthur L. and Eddy N. Smith. *Farmington, Connecticut, the village of beautiful homes.* Hartford, Connecticut: City Printing Company,1906.

Bronson, Henry, M. D. *The History of Waterbury Connecticut; The Original Township Embracing Present Watertown and Plymouth, and Parts of Oxford, Wolcott, Middlebury, Prospect and Naugatuck with an Appendix of Biography, Genealogy and Statistics.* New Haven, Connecticut: T. J. Stafford, 1858.

Gangloff, Rosa F. *The Story of Thomaston It's Origin and Development.* Waterbury, Connecticut: Speed Offset Printing, 1975.

Hill, Susan Benedict. *History of Danbury, Conn. 1684-1896 from Notes and Manuscript Left by James Montgomery Bailey.* New York, New York: Burr Printing House, 1896.

John Banks' Civil War Blog. http://john-banks.blogspot.com/search?q=manross.

Lumpkin, Elizabeth Welton. *History of An Old Hill-town Parish St. Peter's Plymouth, Conn. 1740-1940.*

Pape, William J. *History of Waterbury and the Naugatuck Valley Connecticut, Illustrated Volume I.* Chicago-New York: The S. J. Clarke Publishing Company, 1918.

Peck, Epaphroditus. *A History of Bristol, Connecticut, Pre-Revolution Episcopal Church in Bristol, CT*. Hartford, CT: Lewis Street Bookshop, 1932. http://www.rootsweb.ancestry.com/~ctahgp/history/bristol2.htm.

Pond, E. Leroy. *The Tories of Chippeny Hill, Connecticut*. New York: The Grafton Press, 1909.

Porritt, L. K. *Tunxis Valley Indians*. Canton, Connecticut: The Canton Historical Museum, October 1973.

Smith, Eddy N., Smith, George Benton, Dates, Allena J. *Bristol, Connecticut In the Olden Time, New Cambridge which includes Forestville*. Hartford, Connecticut: City Printing Company, 1907.

Taylor, John M. *The Witchcraft Delusion in Colonial Connecticut 1647-1697*. Bowie, Maryland: Heritage Books, Inc., 1898.

Trumbull, J. Hammond, L. L. D. *The Memorial History of Hartford Connecticut 1633-1884 Volume I*. Boston, Massachusetts: Edward L. Osgood Publisher, 1886.

Woodruff, George C. *The History of the Town of Litchfield, Connecticut*. Litchfield. Printed and Published by Charles Adams, 1845.

www.connecticuthistory.org